WILLIAM HOGARTH

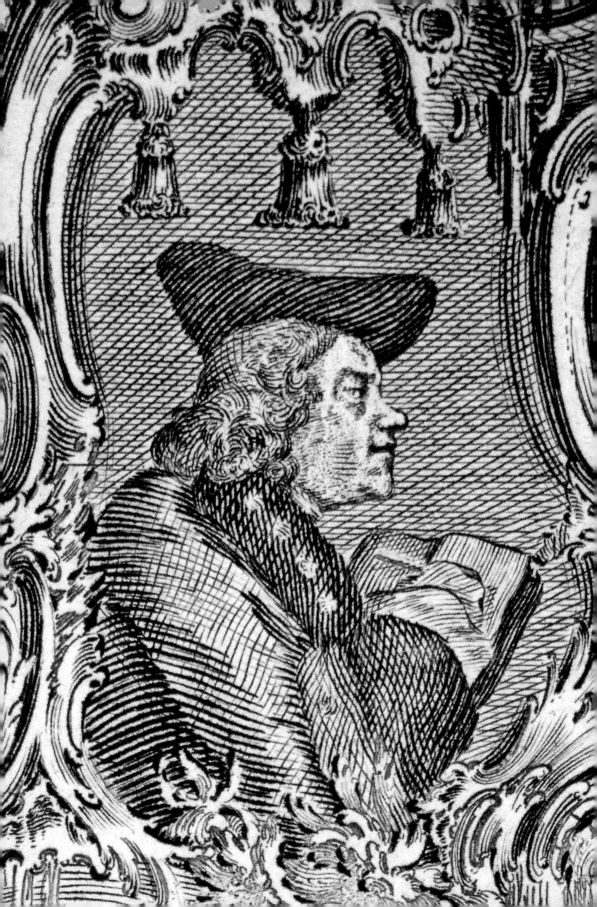

WILLIAM HOGARTH

Matthew Craske

British Artists

Tate Publishing

To Mum and Pup

Front cover: William Hogarth, *The Painter and his Pug* 1745 (detail, fig.24)

Back cover: William Hogarth, *Tailpiece: The Bathos* 1764 (detail, fig.59

Frontispiece: *Mr Hogarth's Head* (detail, fig.7)

Published by order of the Tate Trustees by Tate Gallery Publishing Ltd
Millbank, London SW1P 4RG

© Tate Gallery Publishing Ltd 2000

The moral rights of the author have been asserted

ISBN 1 854 37332 3

A catalogue record for this book is available from the British Library

Cover design by Slatter-Anderson, London

Concept design James Shurmer
Book design Caroline Johnston

Printed in Hong Kong by South Seas International Press Ltd

Measurements are given in centimetres, height before width, followed by inches in brackets

CONTENTS

INTRODUCTION

William Hogarth (1697–1764) qualifies on numerous criteria as one of the most important artists of eighteenth-century Europe. He was the first European artist to initiate a concerted campaign to create, and promote in the public realm, types of art that expressed national identity. It is perhaps ironic that this champion of national independence, and the supposedly idiosyncratic attributes of a national culture, should have had a major international impact. His widely distributed prints, which influenced artists and entertained collectors all over Europe, had a more widespread public than the art of many of his later eighteenth-century compatriots who entertained artistic ideals of a more cosmopolitan nature.

Although it would be an exaggeration to describe Hogarth as 'the founding father' of British graphic satire, it would be difficult to appraise the work of his successors in this genre – Rowlandson (1756–1827), Gillray (1756–1815), Cruikshank (1792–1878) – without reference to his innovations. Hogarth's role in the formation of numerous familiar forms of modern graphic communication is sufficiently obvious to be all too frequently overlooked. Although he did not, strictly speaking, invent the process of telling a story through a set of consecutive images, his print series can validly be regarded as a step towards the modern comic strip and, by extension, the animated cartoon.

Perhaps because Hogarth's art has been perceived conventionally to have derived from literary roots, and his imagery to be readable as much as observable,[1] he has had an enduring appeal to writers. In his lifetime his name appeared with greater frequency in the London press than any other visual artist. The decades after his death saw no reduction in the stream of literature. Hogarth's reputation and significance were debated by among others Horace Walpole, William Gilpin, William Hazlitt and Charles Lamb. More recently, he has had numerous biographers. In the last thirty years two ambitious biographical works have been published, the first by Ronald Paulson and the second by Jenny Uglow.[2] The narrative of his life is one of the most well-trodden territories of modern art history.

This being the case, I decided to write this book as something other than a chronological life story. In the interests of arriving at a fresh perspective on Hogarth's life I have chosen to reveal his artistic personality through a series of thematic essays, each devoted to an aspect of the social and cultural history of the period that I consider to be particularly applicable to his life and art. I proceed from the assumption that Hogarth was, despite a certain resolute independence of spirit, the product of a wider culture and society. Indeed, his very 'independence' can be considered a reflection of a broader political and religious ideology. To justify this socio-historical stance, I will begin with a short account of why Hogarth needs to be assessed with an eye as much on the character of 'the times' as on the character of the individual.

I stress from the beginning that my analysis concerns both the individual and the society. Hogarth cannot be considered a mere conduit for the expression of the concerns of 'a society' or of a class within society. The individual circumstances of Hogarth's life – his upbringing, specific circles of friends, career path – are highly relevant to the imagery of his art, though it would be naïve and anachronistic to regard his work as an extended exercise of self-revelation.

Because I weave the story of Hogarth's life into that of his art and society, it is necessary to provide some basic chronological account of that life. To compensate for the interpretative 'spin' placed on the events of Hogarth's life in the main text of this book, this introductory account is intended to be as impartial as possible. Whereas I make no apology for the fact that the interpretative framework of the book is controversial, I hope that the rest of this introduction will constitute as objective a set of chronologically ordered facts as any historian can hope to attain.

William Hogarth was born in London in 1697. He was son of a schoolmaster who opened a Latin-speaking coffee house. His father fell into debt and on that account was held in the Fleet Prison in 1707. In 1713 William was apprenticed to a silver engraver for a seven-year term. Seven years later, in 1720 he set up as an independent engraver and began thereafter to produce prints. Among his most important prints of the 1720s were satires on the South Sea (1720 and 1724, fig. 32) and Lottery schemes (1724), and a set of illustrations for an edition of Samuel Butler's *Hudibras* (1725). On setting himself up independently, Hogarth subscribed to the Academy of the painter John Vanderbank (1694–1739) in St Martin's Lane and for the next thirty years was identified with a group of artists known as the 'St Martin's Lane Circle'.

In about 1726 he began to aspire to be a painter and for the next few years devoted part of his energies to learning to paint in oils. At this time he started to consort with the circle of the most eminent British-born painter of the era, Sir James Thornhill (1675–1734). Becoming familiar with Thornhill's family, he formed a relationship with his daughter whom he subsequently married after an elopement. In 1729 Hogarth achieved his first major success in the medium of oils with a painting of *The Beggar's Opera*, which depicted a scene from John Gay's play of that name (fig. 21). So successful was this painting that five versions were produced. Over the next ten years he developed a business as a portrait painter which provided subsidiary income within a flourishing career as a producer of satirical prints. Although he painted portraits of individual sitters, his public reputation in this field was largely based on 'conversation pieces'. His mastery of this genre, which featured groups of interrelating figures in domestic interiors, is revealed in *The Wollaston Family* (1730), *The Cholmondley Family* (1732), *Lord Hervey and his Friends* (or *Conversation Piece*) (1738, fig. 26), and *Lord George Graham in his Cabin* (1745, fig. 57).

The major turning point of Hogarth's career was the production in 1732 of his first print series which he entitled *A Harlot's Progress*. This told, in six images, the tragic story of the life of a country girl exposed to the temptations of London life (figs. 1–6). Hogarth came to regard the idea of telling a story through a series of images as the greatest innovation of his career. The *Har-*

lot's Progress proved a great commercial success, so he produced a further series which he called A Rake's Progress (1733–5, figs.29, 30). Here he related the narrative of the decline into penury and madness of a young man who inherited riches from a miserly father. This series was based on a set of finely painted images which are now preserved in the Soane Museum.[3] In anticipation of making a good proportion of his living from prints on subjects of his own invention, Hogarth entered an alliance with a group of London artists to effect a change in the law to protect their copyright. This campaign was successful. A statute, which later became known as the 'Hogarth Act', entered the annals of English law in 1735.

With his commercial career going from strength to strength, Hogarth began in the mid-1730s to involve himself with London charities. In 1734 he engaged to paint, free of charge, New Testament scenes for the staircase of St Bartholomew's Hospital. At some time in the 1730s he came into the acquaintance of Captain Thomas Coram, who had succeeded in establishing a charity for the relief of London's foundling children. On becoming a foundation governor of this charity, Hogarth saw the opportunity to use the publicity generated to promote the visual arts. It was probably his idea to use the Court Room of the Hospital as a place of exhibition for the work of a group of London's painters and sculptors. Hogarth himself donated a magnificent portrait of the founder, Thomas Coram (completed 1740, fig.47), and a fine canvas depicting the Old Testament scene of the infant Moses brought before Pharaoh's daughter (1746, fig.49). Hogarth's practice of donating paintings to charity in this period was strongly linked with a campaign to establish a market for the works of London's native and permanently resident artists. This campaign was directed against the activities of cosmopolitan connoisseurs and auctioneers who were seen to patronise the art of foreigners who played no role in the national economy.

Hogarth's public fame reached new heights in the mid-1740s. At this stage he embarked on another ambitious series, Marriage A-la-Mode (1743–5, fig.25). This took the by now familiar form of a group of consecutive scenes. It revealed, in six parts, the story of a fashionable marriage between the idle and feckless son of a peer and the daughter of a prosperous merchant who is highly susceptible to the corrupting influence of high society. This dynastic alliance, made for reasons of financial expedience, is seen to visit death and disaster on both families.

Having created this tale of the moral foibles of 'high life', Hogarth turned his attentions to the production of prints revealing the causes of social malaise in the lower stations of society. His ventures in this form began with a further innovation, two comparative series revealing contrasting paths of vice and virtue. These series, the twelve scenes of the lives of the Industrious and Idle Apprentice, were followed by a further set of prints aimed at exposing the causes of moral degeneration among the 'common sort', The Four Stages of Cruelty (1751, fig.12).

The 1750s saw no diminution of Hogarth's creative energies. Finding himself to be a successful man whose views on painting much intrigued the public, he set out to publish a collation of his theoretical musings. This publi-

1–6 A Harlot's Progress 1732 Etching and engraving The British Museum

1 Plate One: Ensnared by a Procuress 28.3 × 37.5 (11⅛ × 14¾)

2 Plate Two: Quarrels with her Jew Protector 30.2 × 37.2 (11⅞ × 14⅝)

3 Plate Three: Apprehended by a Magistrate 28.3 × 37.8 (11⅛ × 14⅞)

4 Plate Four: Scene in Bridewell 30.2 × 37.8 (11⅞ × 14⅞)

5 Plate Five: Expires while the Doctors are Disputing 30.5 × 37.5 (12 × 14¾)

6 Plate Six: The Funeral 28.3 × 37.8 (11⅛ × 14⅞)

1

2

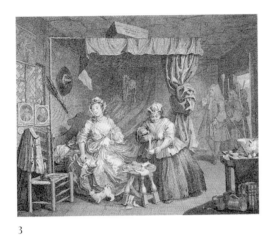

3

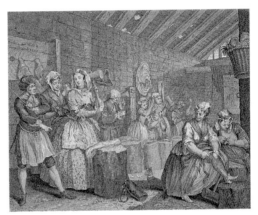

4

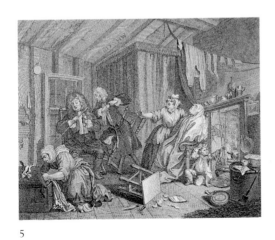

5

6

cation, which was entitled *The Analysis of Beauty* (1753), caused a major stir and inflicted on Hogarth his first taste of protracted public scorn. From the publication of the *Analysis* until his death Hogarth was prone to considering himself a man besieged by his critics.

Despite the jibes of his detractors, Hogarth succeeded in demonstrating in his maturity the depth of his talents as a painter. Nowhere were these talents more evident than in his final series, *An Election* (1753–5). The four oil paintings on which this series of prints were based have survived and are often considered his greatest achievement as a painter (figs.16, 44, 45, 46). These works are about party politics without revealing the party political prejudices of the artist. However, Hogarth could not maintain a course of political independence. In November 1762 the ailing painter entered the party political fray with a print entitled *The Times* (fig.41). This attack on the policies of the Pitt party brought about a public dispute between Hogarth and his former friend John Wilkes who served as Pitt's principal propagandist. The vitriol of this dispute dominated Hogarth's last years. He approached the spectre of death, which finally claimed him in August 1764, a disappointed but wealthy and famous man.

1

THE FREEDOM OF THE TIMES

No other artist has been so consistently seen to define his times and culture as William Hogarth. It is entirely commonplace to encounter references to the mid-eighteenth century as 'the age of Hogarth' or some such phrase.[1] To blame the currency of such clichéd period terms on the lazy tendency to summarise whole cultures in terms of the experience of some supposedly representative figure would, perhaps, be a little harsh. There is much justice in the claim that Hogarth himself set out on numerous occasions to define his 'times' and reveal his society.[2] His sustained commercial success as a social satirist suggests that his contemporaries found him a reliable witness of their most pressing moral and cultural concerns.

If we were to have to invent descriptive phrases to replace 'the age of Hogarth', the 'age of liberty and commerce' would suffice, although itself a cliché.[3] During his lifetime Hogarth witnessed the transformation of his country into the most prosperous state in Europe, after having been at the time of the Restoration (1660) a nation in the shadow of half a dozen wealthier powers. It is difficult to explain this rise to prosperity without accepting some contemporary political rhetoric linking the British people's rediscovery[4] of their traditions of liberty with their new-found prosperity. Years of civil war and religious conflict had left the country in economic tatters. In the final two decades of the seventeenth century consensus shifted towards the production of a culture in which tolerance was expected to give rise to prosperity and a climate of civic concord. This expectation was amply vindicated by eighteenth-century experience.

One of the principal consequences of the efforts to realise the ideal of tolerance was a gradual collapse of the barriers, both legislative and effectual, that prevented expression of opinion in the public realm. This led to rapid growth in the production and consumption of all sorts of printed ephemera and a dramatic widening of the portion of society with access to knowledge and the ability to influence the course of affairs.[5] An important aspect of the 'paper culture' that thrived under these conditions was the satirical and political print. This genre of cultural expression flourished in England as nowhere else, forming a major vehicle for forms of potentially subversive social criticism that would have been immediately suppressed in more authoritarian European countries. By the 1740s William Hogarth was not just a famous figure in the world of the British pictorial print but *the* face of that sphere of commerce. Indeed, at this time one of the most important London print dealers and publishers quite literally traded on Hogarth's famous face. He took 'Mr Hogarth's Head' as his shop sign and the name of his premises (fig.7). Aside from print publishers and salesmen, Hogarth was the one individual of his era who

earned a fortune from the business of graphic satire.

The extent of the public appetite for satire, both graphic and literary, is an indication of this liberal society's anxiety to find its own internal systems of moral restraint. It was an inescapable fact that a society founded on the values of liberty stood constantly on the verge of degenerating into a world where men and women felt they had licence to behave as they wished. Satire can be seen to have arisen as a cultural means of preserving the line between liberty and licence, a means of stimulating within the public domain that sense of moral and religious conscience that acted as the most efficient inhibitor of the selfish will. William Hogarth's career as an artist was dedicated to the business of educating citizens to exploit their national liberties in a reasonable and responsible manner. He set out to turn an art form made possible by the social system of liberty into an instrument for preserving that system from its own tendency to degenerate into a shambles of libertinism.

7 *Mr Hogarth's Head*
1749
Etching
22.2 × 17.5
(8¾ × 6⅞)
The British Museum

Degeneracy is a core concept of Hogarth's art. His reputation was, and remains, largely dependent on his print series which depict the 'progress' of stereotypical characters through life. The majority of Hogarth's print series are cautionary narratives of personal degeneration, illustrating the manner in which such failings as lack of reason, misplaced ambition or idleness could bring men and women down to ignominious ends. Each of Hogarth's degenerates was given a jocular name indicative of their predominant failing. The subject of the first series, *A Harlot's Progress* of 1732 (figs.1–6), was awarded the surname 'Hackabout', to remind the viewer of her vulgar Yorkshire origins and clumsy adventure through life. The second series, *A Rake's Progress* of 1733–5, took as its subject a young heir who is named 'Rakewell' on account of his tendency to do 'well' at all those vain and feckless thing expected of his degenerate type.

This preoccupation with degeneracy links to a wider cultural concern with its opposite, the notion of self-improvement. Britain, as we shall see, enjoyed an international reputation as a society of personal opportunity, a place where hard work had immediate rewards in social advancement. Hogarth was, in many ways, a model self-made man, an incarnation of a national dream. His personal desire to better himself through his art was naturally related to his insistence on the idea that men and women were responsible for their destinies and accountable for their successes and failures. Men's passive submission to the temptations of the corrupting material world was one of Hogarth's prime concerns. He was an artist whose social agenda was focused on alerting his peers to the dangers of being morally devoured by a world of

12

material consumption. His art marks the emergence of a world in which consumer goods came both to define personal aspirations towards free will and to subjugate the individual in a new system of slavery, conformity to fashion and irrational codes of 'taste'.[6]

Discussion of the serious objectives of Hogarth's work should not divert us from the fact that he was primarily famous in his day as a humorist and emerged from a culture that placed great stress on laughter. The links between the rise of humorous art forms and the emergence of political ideals of liberty are complex, reaching well beyond the demand of a tolerant society for the internal restraints of satirical criticism. There was a profound link between the flourishing of humour and changes in social attitudes towards the pursuit of pleasure. It is no coincidence that the initial rise of satire in Britain occurred in the period immediately after the restoration of the monarchy, the formal closure of an era when dour Cromwellian order had prevailed. The rise of a laughing society can be associated with the anxiety of élite culture to establish a new kind of freedom, a freedom to enjoy oneself that was expressed as an escape from the restraints of 'gloomy' Puritan religiosity.[7]

By Hogarth's generation it was becoming evident that the first phase of this search for liberty, which centred on the decadent court of Charles II, had overstepped the bounds of acceptability.[8] When eighteenth-century commentators sought to trace the origin of English libertinism, they frequently referred to the Caroline cult of aristocratic misbehaviour championed by such figures as the hell-raising peers, Lord Rochester and the Duke of Wharton.[9] In the 1680s a more measured programme of escape was suggested by writers associated with a new cult of 'English Epicureanism', most notably the playwright William Congreve. Such Epicureanism was in turn to be supplanted by codes of restraint that placed great emphasis on the moral responsibilities of pleasure-seeking. The turning of the tide against the humour of Congreve, whose plays were performed with decreasing frequency by the mid-1750s, is a signal of the insistence within mid-eighteenth-century polite society on the role of laughter in alerting men to the importance of listening to their moral conscience and acknowledging the pull of their sympathetic emotions.[10] In the manner of his friend, the novelist and magistrate Henry Fielding, Hogarth aimed to create a socially therapeutic humour. Fielding claimed in his *Historical Register of the Year 1738* that his aim was 'to expose the reigning follies in such a manner that men shall laugh themselves out of them before they feel they are touched'.

It is important not to confound the moral humour of men such as Hogarth and Fielding with the denial of the pleasures of sex and convivial company. On the contrary, their focus was on endorsing such pleasures by showing that it was possible to enjoy the fruits of God's providence without becoming a degenerate. Their humour was unmistakably based on defining the moderate course between the legitimisation of pleasure and the restraint of such vices as consumed the person who had gone beyond the reach of conscience.

2

THE IDEALS AND REALITIES
OF SELF-IMPROVEMENT

Eighteenth-century Britain was, as numerous foreign observers testified, a land where money-making was admired. It was considered that in Britain, a country marked by the absence of those formal and rigid systems of rank that prevailed in much of continental Europe, individuals were able to advance to the highest echelons of society without disguising their involvement in trade. Many believed, perhaps without foundation, that this rendered the British class fabric more permeable than elsewhere in Europe.

Fundamentally, it was the buoyancy of the national economy in the first half of the eighteenth century that gave succour to the ideal of self-improvement. Had men of the 'middling sort', such as Hogarth, possessed the liberty to rise in society but not operated in an economic structure that enabled them to do so, they would, surely, have lost faith in the whole ideal. Liberty was, nevertheless, seen by this class of men as the foundation of their hopes for self-improvement, since it was considered that conditions of political liberty fundamentally favoured economic prosperity. A notable English conduct manual of the period, a publication founded on the notion of self-betterment, put this case emphatically:

> Where there is liberty, there will be riches and plenty also; and where these abound, learning and all the liberal arts, will immediately lift up their heads and flourish to advantage. Ease and plenty are the great cherishers of knowledge; as a host of the despotic governments of the world have neither of them, they will naturally over-run with barbarity and ignorance.[1]

The system of liberty and opportunity that mid-eighteenth-century citizens lauded was, essentially, a product of recent political events. Despite the fact that eighteenth-century Britons of all political hues traced the national tradition of political liberty back at least as far as Saxon times, the idea of the 'open élite' only really rose to prominence after the so-called 'Glorious Revolution' of 1688.[2] This 'Revolution' established a limited monarchy that was effectively appointed by parliament.[3] With the emphatic closure of all monarchical pretensions towards absolutist authority, the organs of church and state began to seem, in theory at least, geared towards the realisation of the aspiration of every 'free-born' individual towards self-improvement.

The idea of Britain as a land where liberty spawned opportunity can be regarded as both a reality and a myth. Persons of the 'middling sort', in particular publishers and professional writers, began to gain control of society as

conceived as a 'sphere' of public opinion.[4] Nevertheless, this should be tempered by the knowledge that the organs of government and public service remained dominated by a traditional 'blood' élite. A number of recent historians have pointed out that this élite was in practice highly resistant to the entrance of 'new men' and that this was, in consequence, 'an Aristocratic Century'.[5] Much as the traditional apex of society was more rigidly ensconced than some imagined, so it also remained a reality that most persons who were born into the 'lower orders' were faced with little prospect of escape from their condition. The nation rejoiced in tales of meteoric ascent, such as that of the Craggs family's exaltation from a cobbler's hovel to the office of the Secretary of State in one generation. These were, however, no more than spectacular exceptions to the rule, which to some degree created a climate of false hope.

For the majority in lower stations of life the notion that hard work and virtue would be rewarded by a trip up the social ladder was no more than a pipe dream. It is not unusual to discover those who founded their fortunes on their own talents acting as the most forthright advocates of the idea that the majority of society should be content with a life of hard labour and the consolation that God had ordained such a social order. Hogarth's friend, the novelist Henry Fielding, was the most eloquent proponent of the argument that high levels of crime in mid-eighteenth-century society had their roots in the abhorrent discontent of the lower orders with their allotted social role of unquestioning mundane toil.[6]

As in other European societies, drunkeness and gambling formed the practical consolation for lack of opportunity. Despite unrivalled resort to the death penalty, Britain continued to be a society particularly marked by the riot of the disaffected.[7] Sectors of society that could be expected to have most cherished the dream of self-improvement, such as boys placed into apprenticeships in useful trades, proved highly volatile and subject to affray. It is an indication of the lack of confidence in the national ideal of material self-betterment that a high proportion of London apprentices in the mid-eighteenth century opted to break the terms of their employment.[8]

It was against this background that Hogarth completed his most notable and obvious attempt to employ his art in the promotion of the ideal of self-improvement in London society: his twelve prints charting the lives of the Industrious and Idle Apprentice (published 1747). The prints describe the progress through life of two apprentices who begin their careers working on neighbouring weaving frames (fig.8). One, who is suitably named 'Goodchild', has a propensity towards hard work and virtuous habits. His companion, 'Thomas Idle', is both lazy at work and dissolute in his spare time. 'Goodchild' progresses on a path towards fortune and rank, eventually becoming Lord Mayor of London (fig.9). 'Thomas Idle' is drawn into a life of depravity and calamity which has its conclusion on the gallows at Tyburn (fig.10).

Hogarth's two apprentices are presented as fated individuals. In the first print of the series Hogarth placed the Lord Mayor's mace of office at the margins near the figure of 'Goodchild'. The figure of 'Thomas Idle' is, by contrast, accompanied by irons and a hangman's noose. Had Hogarth been a Calvinist, and persuaded of the validity of the doctrine of predestination, it would be

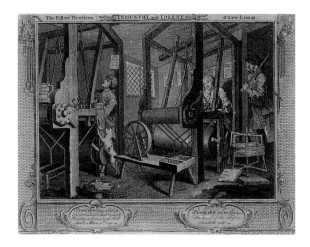

8 *The Fellow
'Prentices at their
Looms* 1747
Etching and
engraving
26.5 × 35
(10⅜ × 13¾)
The British Museum

valid to see these prints as describing the determination of human affairs by a God-ordained destiny. However, when we look closer at these prints, as we will later in this book, there can be little room for doubt that Hogarth's vision was much at odds with Calvinism. His figures are unmistakably responsible for their own destiny: their choices determine their fate. The central function of the print series, which was published in the simplest of engraved forms to ensure a low cost, was to encourage those in a similar station of life to emulate the pattern of choices taken by 'Goodchild'. Much as the moral system of these prints is opposed to Calvinism, it is fundamentally anti-Catholic. In a Catholic moral universe 'Goodchild' would have received his ultimate reward in heaven. Hogarth suggests that the rewards of virtue should be both material and social. A practical moralist, he believed that only rewards and punishments that could be plainly seen and experienced could act as effective stimuli to good social behaviour.

In the mid-1740s William Hogarth was an artist well placed to promote the notion of self-improvement. It was well known that he had been 'self-taught' and had risen from the most discouraging of social circumstances.[9] His achievement, in the period between 1726 and 1729, of teaching himself to paint in oils was portrayed as an exemplary triumph of talent over adversity. His transition from metal engraver to oil painter constituted a symbolic shift from the orbit of the 'mechanic' trades to that of the 'polite arts'. Such improved status was sufficient to propel him into the society of the great. Within a few years of learning the art of oil painting he had obtained portrait commissions from a host of the country's most distinguished families. Even royal patronage was secured, leaving posterity with a fine image of the young Duke of Cumberland.

Hogarth's prospects were sufficient to persuade the daughter of the most famous early eighteenth-century English painter, Sir James Thornhill, that he would make a suitable husband. It is a credit to his charm and tenacity that, some months after the elopement, he even managed to persuade Sir James of this. To marry into a family that practised one's trade, or some variation on it, was conventional at this time. Nevertheless, it was exceptional for a man of

Hogarth's lowly origins to entertain ambitions of marrying the daughter of a person of Thornhill's social standing, for Sir James derived from an ancient landed family and had a seat in the House of Commons.[10]

In this marriage Hogarth anticipated the conduct of his own invention, 'Goodchild', whose merits were rewarded with the hand of the daughter of the most respectable and dignified representative of his line of business. As his career prospered, Hogarth was able, like his fictive hero, to indulge in generous charitable services to his civic community, serving as a governor of St Bartholomew's Hospital and the Foundling Hospital as well as Bedlam[11] and Bridewell. Through such charitable offices both Hogarth and his fictional protégé were able to demonstrate the idea that private virtue and industry could have considerable public benefits.

The real city of London was not a place in which blithe virtue so easily prevailed as it did in the ideal world of 'Goodchild'. While 'Goodchild' inhabited a world in which a virtuous man could passively rely on God's providence to bring him rewards, Hogarth himself was quick to realise that real society provided no material rewards for the man who failed to take active steps to attain them. Hogarth was not simply industrious, he was sharp and entrepreneurial. Commentators on the artist frequently neglect to emphasise that he was a highly resourceful, even innovative, businessman. Throughout his career he

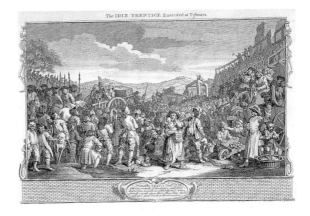

9 *The Industrious 'Prentice Lord Mayor of London* 1747
Etching and engraving
26.5 × 35
(10⅜ × 13¾)
The British Museum

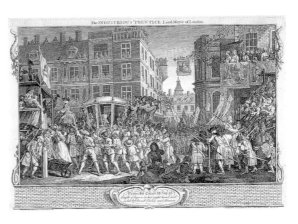

10 *The Idle 'Prentice Executed at Tyburn* 1747
Etching and engraving
26.5 × 35
(10⅜ × 13¾)
The British Museum

used every legal means of promoting his art. His prints were packaged and advertised with great flair. He conducted numerous publicity stunts and managed to develop a cult of personality around himself that kept the public gossiping about his activities as they did about no other artist. Indeed, his fame and notoriety were only rivalled by that of prominent actors and actresses. Particularly in the last years of his career, he benefited economically from the tendency of the public to speculate about his intentions and motivations. With his own collusion, his life became a drama in which every coffee house gossip had a stake. So famous were his personal disputes that he was able to make a great deal of money from producing prints that related to them. He himself confessed that a satire he made about his former friend, the political propagandist John Wilkes, had sold with unprecedented alacrity.[12]

In reality, as opposed to the ideal world of 'Goodchild', Hogarth found London to be a social environment that was supremely unfavourable to the interests of merit and virtue as he understood them. Of all artists of his day, he was the most zealous to change the patronage conditions and attack the commercial system that was associated with the suppression of the emergence of a meritocracy. Most conspicuous of his projects was the scheme, which was successfully concluded in 1735, to change the copyright law to protect the intellectual property of artists. While aimed at the protection of private interests, this act was also intended to promote the public good by encouraging men of 'inventive' capacities to believe that they, not their copyists, should profit from their endeavours.[13]

Although Hogarth's own life can be associated with that of the Industrious Apprentice, it is important to realise that he saw the path to economic betterment that could be taken by the painter as entirely different from that of a tradesman. He was acutely aware that a painter required more than hard work to attain fame and fortune. In the anecdotal account of his own life which he wrote in the last years of his life Hogarth makes every effort to credit any success he had in his career to his natural 'inventive' prowess. On several occasions, indeed, he refers to himself as a person naturally inclined towards 'constitutional idleness', in order to stress the point that it had taken more than work to make him famous.[14] He was acutely aware that the quality of works of polite taste was far more difficult to determine than the ribbons of cloth woven by 'Goodchild'.

That paintings could not be as easily evaluated as simple consumer goods was a reality that Hogarth both rejoiced in and railed against. In his biographical anecdotes he laments the fact that, while a life of merit and endeavour would inevitably lead to the enrichment of a man of business, an artist had to deal with an absurd market in which no such logic prevailed. Hogarth argued that Britain was a country that rewarded mundane trade and industry but had little idea of how to evaluate and encourage the endeavours of those with more sophisticated productions on their mind:

> Whether it is to our honour or disgrace, I will not presume to say, but
> the fact is indisputable, that the public encourage trade and
> mechanics, rather than painting and sculpture. Is it then reasonable

to think that an artist, who, to attain essential excellence in his profession, should have the talents of a Shakespeare, a Milton, or a Swift, will follow this tedious and laborious study merely for fame, when his next door neighbour, perhaps a porter brewer, or an haberdasher of small wares, can without any genius accumulate a small fortune in a few years become a Lord Mayor, or a Member of Parliament and purchase a title for his heir?[15]

Hogarth's answer to his own rhetorical question was to argue that British artists who wished to improve themselves in social and material terms had been required to produce mere consumer products that required no 'genius', as this higher quality was not admired or recognised. By this he meant that public philistinism had forced his brethren into churning out portraits. Such art was seen to satisfy the base 'vanity' of clients. It did not, Hogarth argued, require any intellectual acumen to become a successful portrait painter.[16]

While Hogarth was happy to set some of the blame for the failure of the ideal of a meritocracy in the visual arts at the feet of an uncultivated general public, he was even more inclined to point the finger at those with conspicuous claims to cultivation. Chief culprits for producing this disincentive effect were, in Hogarth's view, picture dealers and cosmopolitan connoisseurs. The former had it in their interest to sustain the highest prices for the works of dead, and invariably foreign and Catholic, Old Masters. The latter, blinded by pretentious and illogical notions of quality, were considered reluctant to support even the most manifestly meritorious works of contemporary British painters.

Part of Hogarth's objective in writing a theoretical tract, *The Analysis of Beauty* of 1753, was to establish a clear set of criteria whereby persons could, by plain reasoning and 'natural' observation, form a sense of taste that would allow painters of merit to prevail.[17] Central to his thesis was the idea that the eye is naturally drawn to, and the mind finds pleasure in, such things as exhibit within their form an elegant serpentine line or 'line of beauty'. It was to prove the single most naïve hope of a man of otherwise canny and pragmatic intelligence that there was some common-sense means of establishing an alternative to the fickleness and vagaries of taste that sustained the perceived injustices of the art market. Despite its bluff and practical tone, it is important to realise that Hogarth's *Analysis* is a work of Don Quixote-like idealism, his mode of windmill-chasing being the attempt to secure the revolving and unstable standards of aesthetic judgement.[18]

The idealism of the *Analysis* was just one sign that, having made his career on the basis of his humour, the mature Hogarth felt he deserved the luxury of being taken seriously. While the text and illustration of the *Analysis* show glimmers of Hogarth's humour, it was an intensely serious, even scholarly, work. The book was divided into chapters which were given titles to communicate the artist's concern with demanding concepts that had long perplexed theorists: 'Fitness', 'Variety', 'Uniformity, Regularity or Symmetry', etc. Literary friends were engaged to revise the text, ensuring that the artist's innate wit was not eclipsed by his lack of syntactical command.

In the years immediately after the completion of the *Analysis* Hogarth began to turn his attention to painting in 'high' genres associated with the serious drama of classical tragedy. The most notable venture of this type was his *Sigismunda* (first exhibited 1761), a painting based on a story in Boccaccio's *Decameron* (fig.11). The theme of the painting was heart-felt tragedy in both a literal and a metaphorical sense, for it featured the figure of a woman grieving over the heart of her lover. Like the *Analysis*, it brought considerable public derision and calls for the artist to stick to his comic endeavours.[19]

The moral tone of his *Idle and Industrious Apprentice* series of 1747 consti-tutes the first sign that he was ready to turn away from humour. 'Goodchild' was the first paragon of virtue to emerge from Hogarth's imagination. So keen was the artist to produce a gleaming example that he resisted his instinct to subvert appearances. A few years later, when addressing the matter of human barbarity in the form of his *Four Stages of Cruelty* (published 1751), he again appears to have struck on subjects – cruelty to animals, murder and the bar-barity of anatomists – that he considered to be too serious for humorous treat-ment. His prints on the theme of cruelty were engraved simply in order to be affordable to the lower sectors of the market.[20] An attempt was even made to produce the series in woodcut form to further reduce the cost of the social medicine (fig.12). While earlier satirical works are full of subtle and complex allusion, these print series make their point in a stark and unambiguous man-ner. By now Hogarth was in the social and economic position to be able to afford to indulge in earnest sermonising. Having achieved celebrity and a measure of gentility, he could start to talk down to the lower orders and address his art, at least partially, to those portions of society where wealth was not concentrated.

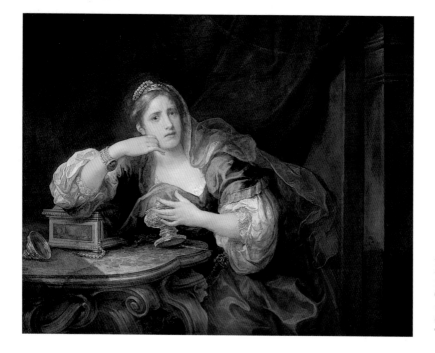

11 *Sigismunda Mourning over the Heart of Guiscardo* 1759
Oil on canvas
100.7 × 126.8
(40 ×49⅞)
Tate

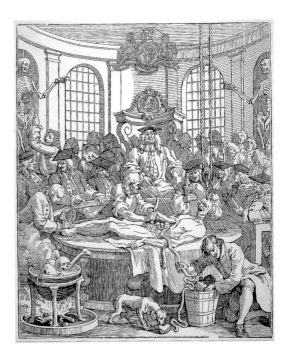

12 J. Bell after
William Hogarth
*The Four Stages of
Cruelty, The Reward
of Cruelty* 1750–1
Woodcut
45.4 × 38.1
(17⅞ × 15)
The British Museum

Previously, until the mid-1740s, Hogarth had set his sights on impressing the minds of those sectors of the population who could afford to subscribe to relatively expensive series of prints – persons of the 'middling sort' and above. His graphic satire of the 1730s and early 1740s proliferated with humorous and moralistic references which would have been lost on those without at least a smattering of classical education, some experience of prominent sermon writers, and a knowledge of the writings of essayists working in the tradition of Joseph Addison whose famous articles in the *Spectator* (1711–12) had set out to bring philosophy into the coffee houses of Britain.

The rise of his career can be detected in the general upward trajectory of the social milieux that were the object of his satirical attention. His first print series, *A Harlot's Progress* (figs.1–6), depicts the life of an ordinary country girl who comes into contact with high-life vices. The next series, *A Rake's Progress*, centred on the tragic degeneration of an heir to a gentry family who falls into bad company. In the early 1740s Hogarth's satirical attentions moved towards the failings of the most fashionable quarters of society. Under the stimulus of a loyal patron, Mary Edwards, he published a print exposing the fripperies of fashionable society under the title of *Taste in High Life* (fig.13). This print can be accurately described as an 'in joke' of high society. It was no secret that Mary Edwards had not just commissioned but designed this image in order to have public retribution on peers who had mocked her somewhat old-fashioned ways and apparel. Here, in an image that bore witness to his friendship with a woman at the apex of society, Hogarth signified most clearly that he had arrived, that he was sufficiently part of the fashionable domain to act as a vehicle for an internal critique upon its excesses. This print was followed by his *Marriage A-la-Mode* (1743–5) series, which charted the progressive decline of

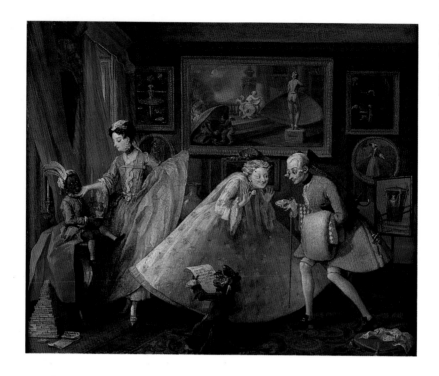

13 *Taste in High Life*
*c.*1742
Oil on canvas
63 × 75
(24⅞ × 29½)
Private Collection

families representative of the highest social standing in country and city, the daughter of an alderman and the son of a gouty aristocrat.

It was only after having gained his fortune with such an ascending target list that Hogarth was able to make public his concern with the vices and virtues of persons of lowly stature. In the late 1740s and 1750s he expressed his disgust with the ugly characteristics of the common mob. The mob set the tone of his final series, *An Election* of 1753–5. It gathers in the streets of the *Four Stages of Cruelty*, and brays at the misguided Idle Apprentice as he ends his days at Tyburn. Hogarth was, however, not simply concerned with the vices of the common man. Popular heroes were constructed of the working folk of 'Beer Street' and the robust soldiers protecting Britain from a threatened French invasion. It is as if Hogarth, having gained secure tenure in polite society, began both to reflect nostalgically upon the worthiness of the labouring classes from whose orbit he had risen and fear the power of the mob to denigrate the entire system of politeness that he had striven to penetrate.

In his images of Gin Lane and Beer Street (figs.14, 15) Hogarth has recourse to a moral point familiar to his art: that, from whatever class a person was derived, their destiny was not determined by environmental conditions. In these prints Hogarth employs a favourite device of symbolising the moral decline or advance of individuals in terms of the decay or prosperity of their physical environment. Given Hogarth's prevailing insistence on the notion of personal responsibility, it is clear that we are to interpret the conduct of his subject as forming their environment, not the inverse. In Gin Lane all buildings crumble except the pawnbroker's; only props save some from collapse. Viewers of Beer Street, by contrast, find that only the pawnbroker's is in decay

and that the environment is otherwise well ordered. The distant figures of builders inform us that this is a place of energy and prosperity. The people of the city are seen to make their streets into emblems of their communal condition.

This was not the only occasion when Hogarth indicated that private vices lead to public ruin. In the third image of his *Election* series, for instance, we see the private corruption of those approaching the poll stations, either lured by bribes or inducing the sick and befuddled to vote for their party (fig.16). Behind, a coach-and-horses, symbolic of Britannia, suffers a broken axle. Yet further in the distance a local village and its church lie in ruins, the traditional community dying for the sake of immediate party ambitions.

Hogarth's concern to show the link between private vice and public decay needs to be understood in the context of the central moral debates of the day. In the years when Hogarth had been struggling to make his way in the engraving trade British intellectual culture had been rocked by the re-publication of a scandalous philosophical work, Bernard Mandeville's *Fable of the Bees* (enlarged and revised editions published in 1723 and 1728). Mandeville argued that commercial societies operated on a system of *realpolitik*, whereby private vices provided the essential wealth upon which a prosperous public realm was founded. By this he meant that a folly such as a wealthy woman's vanity would encourage expensive shopping trips that would keep a host of otherwise needy milliners, mercers and haberdashers in employment. The taxes paid by this portion of the body politic would, in turn, ensure the security and prosperity of the state. Mandeville's argument constituted an attack on the classical notion of the ideal state as a realm where private integrity had public benefits, as well as the Christian belief in absolute moral values. Mandeville's opponents, and there were many, saw his thesis as little more than a blueprint for libertinism.

Below left
14 *Gin Lane* 1751
Etching and
engraving
35.9 × 30.5
(14⅛ × 12)
The British Museum

Below right
15 *Beer Street* 1751
Etching and
engraving
35.9 × 30.2
(14⅛ × 11⅞)
The British Museum

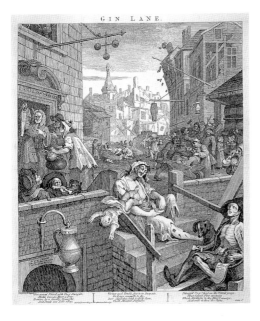

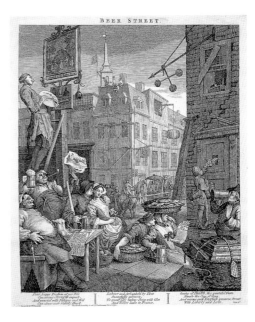

Throughout Hogarth's career the moral focus of his work was on proving the fallacy of this type of libertine social vision. He constructed private worlds in which personal vices had no visible benefits either to the person or to society at large. As we shall see in this book, he placed great weight on the idea that the individual was more than a component of a social 'hive', to use Mandeville's analogy of civic society. Rather, he argued that the individual citizen's responsibility was to transcend those deterministic social forces that sucked persons into systems of depravity.

In his own flawed manner Hogarth conducted his life according to this principle, that only private virtues could contribute to a virtuous public realm. The extreme confidence in the notion that vice and virtue would find their own material rewards, as found in the *Industrious and Idle Apprentice* series, was born of fifteen years of life experience that encouraged Hogarth to believe that the world could be made to operate in this way. Hogarth's rise through society was to a large extent based on revenues generated from producing images of those whose vices contributed to their gradual downfall. The story of his own life, therefore, acted as a fine counterpart to his fictional worlds of degenerative 'progress'. His moral agenda was frequently to show how individuals could be corrupted by the social system of commerce; how the purchase of things such as erotic paintings, and the debts incurred by succumbing to the temptations of the consumer world, could precipitate personal moral degeneration. However, by making his living from the sale of morally instructive works, he demonstrated that the system of commerce could aspire to generate moral improvements in the public realm. His life of making money from civic education could be considered an example of a virtuous circle that gave the lie to the idea that commerce was necessarily a tainted system.

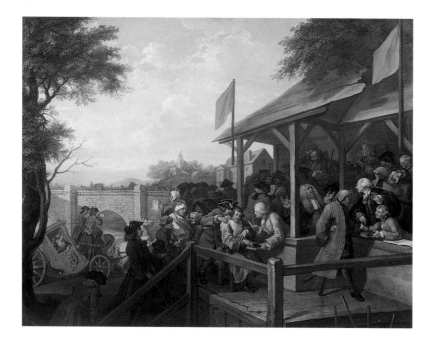

16 *An Election: The Polling* 1753–4
Oil on canvas
101.6 × 127
(40 × 50)
By courtesy of the Trustees of Sir John Soane's Museum

3

'BRITOPHIL'

On 7 June 1737 an anonymous letter from the pen of a certain 'Britophil' was published in the *St James Evening Post*. At its heart was an attack on the conduct of the picture dealers and cosmopolitan connoisseurs who were held responsible for the importation of 'ship-loads of dead Christs, Holy families, Madonnas and other dismal dark subjects'. The writer of the letter accused these portions of society of acting in concert to promote the market for the work of foreign artists, both dead and living, effectively ruining the prospects of the indigenous profession. It was no secret that the author was William Hogarth.[1]

Readers of the London newspapers of the 1730s are unlikely to have found the sentiments of this letter shocking or unusual. The London press of this period proliferated with piquant attacks upon fashionable society's predilection for foreign fripperies, from new styles of wigs to the performances of French strolling players and Italian opera singers. Hogarth's most direct cue, however, was taken from the journalism of his friend James Ralph, editor of the *Weekly Register*. In an essay on painting published in 1733 Ralph had fiercely criticised the importation of foreign and Catholic art which the 'Britophil' epistle closely resembles.[2] Ralph followed up this essay with a concerted attack on the work of foreign mural painters working in London, most explicitly the Venetian muralist Jacopo Amigoni (1682–1752). This onslaught was coupled with a blatant attempt to promote the interests of artists who were associated with the drawing school at St Martin's Lane and the social gathering point of that school, Slaughter's Coffee House.

Of all the artists in this circle, Hogarth was the most heavily 'puffed', though it was his friend, the portrait painter Jack Ellys (1701–57), who was commonly thought to be the ghost behind the text. It was not a coincidence that Ralph's literary assault on Amigoni's murals at the houses of Lord Tankerville and the Spanish Ambassador acted as a prelude to Hogarth offering his services to paint a series of scenes for the staircase of St Bartholomew's Hospital. Largely by working *gratis*, Hogarth was able to supplant Amigoni who had been in consideration for the project. In taking on this commission Hogarth established by practical demonstration the arguments set out in his 'Britophil' epistle, that only an insupportable prejudice in favour of foreign workmanship was blinding patrons to the qualities of British painters.

Hogarth, however, was not simply attempting to show that British painters had the skills to compete with foreigners in the most ambitious genres of painting. He, like Ralph, believed that much foreign art failed to meet the demands of civic education and religious instruction peculiar to national Protestant culture. Ralph attacked foreign art for being 'unmeaning' in

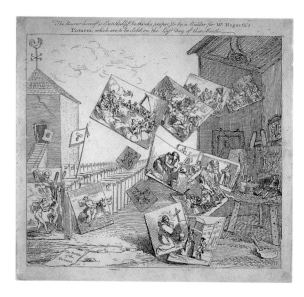

British social circumstances.[3] Hogarth conformed with these sentiments. In a self-promoting print of the mid-1740s entitled *The Battle of the Pictures* he made this point most clearly (fig.17). Imported paintings on mythological and religious themes are seen stacked up in an auctioneer's yard, the majority of the pictures being marked with the word 'ditto' to indicate that, once one has seen the first one, one has seen them all. Imported art is lampooned as merely formulaic. Catholic Europe, which to a reformist Protestant eye was bound to seem a society in an advanced stage of cultural decadence, is perceived simply to rehearse the myths and religious narratives that had once served moral purposes.

A similar point is made in plate 2 of *A Rake's Progress* (fig.18), where the main character of the narrative, Rakewell, is seen to make decisions between various upper class vices – betting, drinking, foreign opera, and duelling – before a mythological painting on the theme of the Judgement of Paris. Had Rakewell understood this scene, he would have appreciated that it was a moral legend concerning the disastrous choices men make when their judgements are addled. Having bought this continental painting at an auction in order to display a certain conventional 'good taste', Rakewell is oblivious to any vestigial moral meanings that reside in the image. The painting communicates a meaning to the viewer of Hogarth's image, because of the way he employs it within his drama. However, to those fictive characters involved in the drama itself it might as well be a 'piece of furniture', to use Hogarth's own phraseology in describing imported pictures.[4]

The perceived lack of invention and novelty in continental art was regarded as a symptom of societies that lived in the drab shadow of a more glorious past and had grown sterile in their inability to find new meaningful narratives and images to sustain their cultures. When we take into account this association between the Catholic continent and the 'unmeaning' repetition of conventions, we are provided with a cultural context in which we can understand

the great store that Hogarth set upon his capacities of 'invention' and the value he placed upon the importance of 'variety' in the visual arts in his *Analysis of Beauty*. It helps to explain, as something more than personal vanity, his boasts that he had created new types of art, which appear in his autobiographical anecdotes. Hogarth considered that art needed to be pregnant with relevant meanings in order to effect social reform. Believing that the public ceased to find meaning in convention, he set out constantly to invent new ways of communicating these meanings. For Hogarth novelty constituted and perpetuated reform. Because the spirit of reform was, in turn, an essential attribute of the Protestant identity, it followed that to seek to invent new and useful things was considered a veritable Protestant virtue.

The tendency within British Protestant culture to value the newly invented gave rise to an attitude of irreverence towards the antique. In the late 1720s Hogarth moved in circles associated with the actor James Spiller who was famous for his parodies of classical figures, most notably Alexander the Great.[5] This was an era in which numerous playwrights set out to poke fun at the pompous ceremony that attended the revival of the Greek and Roman past. Lewis Theobold's *Rape of Proserpine, a Pantomime Opera* (1727) was somewhat typical. The grandiose bluster with which theatre companies had

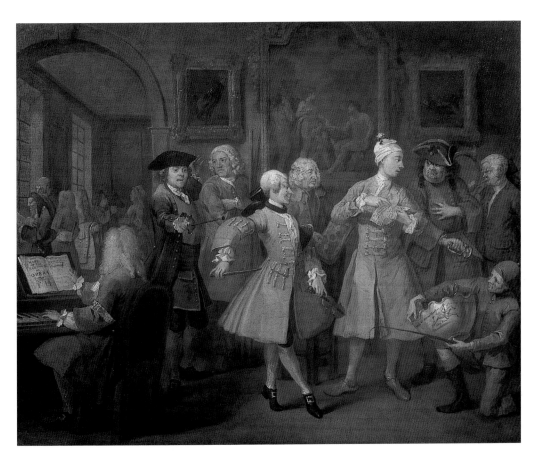

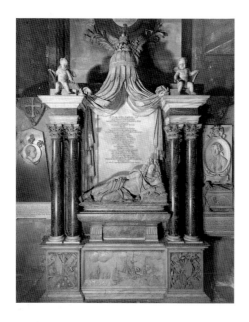

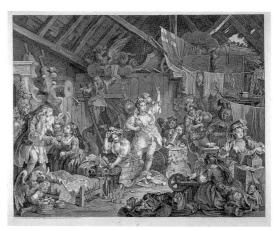

brought their Caesars, Alexanders and Leanders upon the stage was the object of much hilarity.[6] Part of the humour turned on the constant stream of improbable collisions between the inordinate artifice used to create an impression of great historical events and the common prosaic realities of modern life. Where the visual arts strayed into this type of theatre, witty critics were quick to point it out. In a *Spectator* essay Joseph Addison famously satirised the recently erected monument to Sir Cloudesley Shovel for its absurd combination of Parian periwig and Roman armour (fig.19).[7] Following this example, James Ralph in the previously mentioned critiques on Amigoni's murals joked that the story of Antony and Cleopatra had been made to seem like 'the gallantries of some fat rich alderman and his extravagant spouse'.[8]

Hogarth produced the most brilliant satire of this type of pompous artifice in his image of *Strolling Actresses Dressing in a Barn* (fig.20). This print proliferates with visual jokes at the expense of the grandiose props employed in the performance of classical plays. In the foreground a monkey pisses carelessly into the helmet of Alexander the Great, while modern actresses of questionable virtue prepare themselves to play the parts of goddesses and virtuous heroines.[9] That the company use a humble barn in which to transform themselves is indicative of the rustic limitations of their artifice. This rusticity has obvious erotic overtones. The company, reversing the practice of the Shakespearean stage, are, with one exception, entirely composed of women. Since the practice of employing female actors only became acceptable in the reign of the somewhat decadent Charles II, there can be little doubt that Hogarth was poking fun at the degeneracy of the modern stage. As the voyeuristic head appearing through a whole in the roof indicates, the people will turn out to see the company perform to provide them with erotic titillation. The scant clothing and cross-dressing associated with these classical dramas will obviously add to the erotic appeal.

Above left
19 Grinling Gibbons
Monument to Admiral Sir Cloudesley Shovel
1707
Various marbles
Warburg Institute

Above right
20 *Strolling Actresses Dressing in a Barn*
1738
Etching and engraving
42.6 × 54
(16¾ × 21¼)
The British Museum

The desire to expose the vain and lascivious motivations behind the perpetuation of antique myth and history reflected a confidence in contemporary national culture, and this underscored the drive of figures such as John Gay, Henry Fielding and Hogarth to create heroic or counter-heroic narratives out of the events of modern life.[10] Hogarth first established his reputation as an oil painter with a work, *A Scene from 'The Beggar's Opera'* (fig.21), which firmly announced his intention of becoming a critic of the foibles of the modern English world as opposed to a eulogiser of the supposed splendours of the ancient and foreign world.

This painting was based on a scene in the play of that name by John Gay, which had been the sensation of the London stage in 1728. The play, which was first performed at the Theatre Royal, Lincoln's Inn Fields, was controversial because it was shamelessly topical and patently political. Gay was firmly associated with the burgeoning 'country party' opposition to the political administration of Robert Walpole, and his play was, from the very earliest performances, interpreted as a satire on Walpole's claim to integrity and gentility. Gay's theme was the topsy-turvy nature of modern London society in which respectable professionals behave like villains and common rogues assume airs of gentility. His narrative centred upon the conduct of a criminal underclass which covered their base motivations with a veneer of nobility. Contemporaries took it for granted that the character of a socially presuming

21 A Scene from 'The Beggar's Opera' VI
1731
Oil on canvas
57.2 × 76.2
(22½ × 29⅞)
Tate

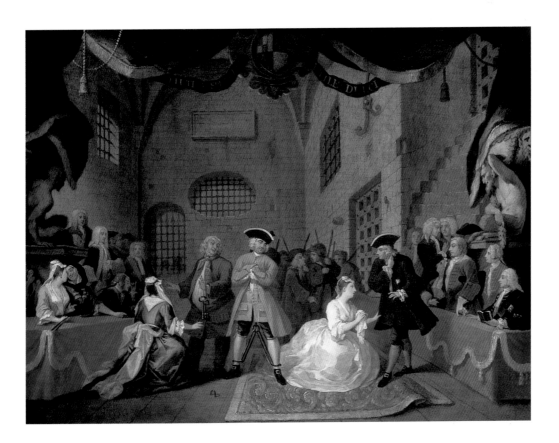

highwayman by the name of Macheath was intended as a parody of Robert Walpole.

The scene of the play that Hogarth illustrated was situated in the most lowly of environments, the interior of Newgate Prison. Macheath is presented as a captive in leg irons posed between the warden of the prison and an informer. Their respective daughters, Lucy Lockit and Polly Peacham, plead mercy for Macheath who is otherwise destined for the gallows. The humble and monotone prison environment makes stark contrast with Macheath's brashly colourful attire which defines his pretensions to be a gentleman. This is a scene of squalor, both environmental and moral. It makes an intentional contrast with the vapid, superficially pleasing scenes that attracted fashionable society to the Italian opera. The gritty modernity of the play, and its heavily moralistic subtext, formed a complete antidote to imported entertainments, which were dismissed by their critics as little more than seductive modes of imaginative escape. Hogarth makes this point clear by presenting on the stage curtain a Latin motto, 'utile dulce', which was drawn from Horace's *Ars Poetica*: 'But he that joyns instructions with delight, profit with pleasure, carries all the votes.'[11] The intimation was, as one perceptive modern critic has shown,[12] that 'manly' English drama could combine instruction and entertainment, putting to shame foreign showmanship that centred on the excitement of effete impulses towards pleasure. Whether Hogarth shared Gay's anti-Walpolian sentiments is highly uncertain. It is, however, clear that he shared Gay's belief that the desire to confront the sordid realities of modern life, and distinguish alluring theatrical appearance from the unvarnished truth, was a national attribute.

Hogarth's use of a Latin quotation in this painting is fascinating. He seems to have been willing to cite the Latin authors but only in so far as they had words of wisdom to offer. Otherwise, he was merciless in his desire to expose the error of a morally vacuous admiration of the antique past. The origins of Hogarth's complex responses to the antique can, perhaps, be traced to his particular personal history. His father had been a scholar of Latin who had been brought to poverty and an early death by an involvement with a failed Latin dictionary and, to use Hogarth's words, the 'disappointment from great men's promises'. The evidence of his biographical anecdotes suggests that childhood experience led Hogarth to associate pandering to the Latinate élite with the degradation of humbly born men of abilities.

The spread of public knowledge about the antique that occurred in the early eighteenth century owed much to the growth of reasonably priced translations and primers on classical history. Hogarth, who confessed his own minimal Latin,[13] may be assumed to have gained most of his knowledge of antiquity from such sources and would have expected a high proportion of the purchasers of his prints to have gained their education in this way. While it might be imagined that reading about antiquity in English would have reduced the sense of the foreignness of Roman and Greek culture, there were also negative consequences. Accessibility and familiarity did not necessarily breed contempt; they did, however, present the possibility of a certain degree of disrespect.

The appearance of jokes concerning the thoughtless combination of the antique past with the trappings of the modern world marks the beginning of the attitude, in some quarters of society, that this past was something foreign. As such, in an age associated with the 'rise of British (or English) Nationalism', the antique past was open to being considered as threatening or silly, as other foreign things.[14] For a figure of xenophobic tendency such as Hogarth, it became possible to regard the Romans and Greeks as just another set of potentially corrupting foreign influences. In a number of works Hogarth communicated the belief that, in common with the consumption of other imported consumer goods, antique culture had to be approached with moral caution.

This idea is most powerfully expressed in a painting of the mid-1730s depicting the signing of a marriage contract (fig.22). In this work Hogarth clearly had in mind an idea of depicting a doomed marriage which was later fully realised in his *Marriage A-la-Mode* series. Part of the bride's 'portion' or dowry appears to be a collection of imported art works, extravagances that are intended to communicate that a lack of moral discernment will bring disaster to the marriage. At the heart of the collection is a group of heavily damaged busts. The names engraved on the socles of the busts show them to be an assortment of heroes and villains of classical history: the bust of the great and virtuous orator, Cicero, is placed directly beside that of Julia, reputed to be a female libertine and accused of incest, among other immoralities. Hogarth's point is that thoughtless connoisseurs followed antiquity in the manner of 'leaden-headed imitators', to use a phrase from the biographical anecdotes,[15] and venerated the ancients without any awareness that they may be taking both good and bad moral examples.

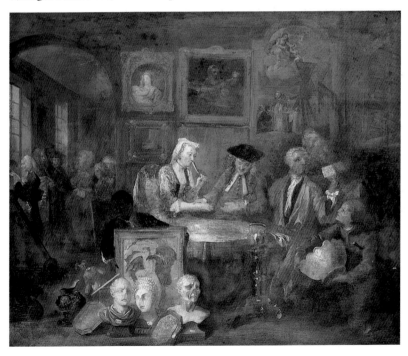

22 *The Marriage Contract* 1732
Oil on canvas
61.9 × 74.9
(24⅜ × 29½)
Ashmolean
Museum, Oxford

Whatever our aspirations toward historical objectivity, it is difficult to avoid being swayed in our attitude towards Hogarth and his art when confronted by his xenophobia and his role in the incitement of public bellicosity. There is a long tradition of finding such tendencies in Hogarth's personality distasteful. The cosmopolitan Horace Walpole, a qualified admirer, deplored his tendency to resort to the incitement of base popular chauvinism as exhibited in prints like his *Preparations for Invasion* (1756).[16]

Hogarth was not above indulging the basest instinct to hate, with visceral unreasonableness, those things that presented a perceived threat to personal territory. Although he was willing to visit the continent to complete his artistic education, Hogarth's attitude to his hosts was sufficiently boorish to embarrass his travelling companions. This personal characteristic was ably expressed in his famous painting of the Gate of Calais, also known as *O The Roast Beef of Old England* (published as a print in March 1749, fig.23). This work was intended as a proud memento of an occasion on Hogarth's second visit to France when he was arrested on suspicion of spying while drawing in the vicinity of the fortifications at Calais. His self-portrait in the act of sketching can be glimpsed behind a group of hideous fishwives who are provided as a sample of the nature of French femininity in the lower orders. Pure contempt for the foreign exudes from his description of this work in his biographical anecdotes:

> The first time an Englishman goes from Dover to Calais, he must be
> struck with the difference of things at so little a distance, a farcical
> pomp of war, pompous parade of religion, and much bustle with very
> little business. To sum up all, poverty, slavery, and innate insolence,
> covered with an affectation of politeness, give you even here a true
> picture of the manners of a whole nation; nor are the priests less
> opposite to those of Dover, than the two shore. The friars are dirty,
> sleek, and solemn; and as to the fisherwomen – their faces are absolute
> leather.[17]

Hogarth's contempt for the foreign was sufficient to encourage him to promote strenuously the kinds of art that were deemed to express the distinctive attributes of national character. In the four decades after his death Hogarth's desire to generate a British type of painting that was distinct from that of any past or foreign school was to seem a dangerous blind alley to the numerous artistic commentators who favoured the direct emulation of continental traditions and standards. As the leading forces in the British art world aspired to create a realm of visual arts that suited the ambitions of a great empire, attention turned to the production of a British visual culture that, after the manner of the coinage of the old Roman Empire, could be recognised as part of a universal currency.

It should, however, be pointed out that those who promoted the universal in late eighteenth-century British art did so from the advantage of a nation that, though threatened by continental war machines, was aquainted with military prowess and trading supremacy. By the 1770s this superior position had begun to extend to the sphere of polite culture, with British fashion, lux-

ury goods and art coming into great demand on the continent. Hogarth, by contrast, inhabited a world in which it was entirely legitimate for a person who lived by his own inventive capacities to feel threatened by foreign culture. For much of Hogarth's life Britain was more conspicuous for its wealth than its might and international cultural influence. Throughout the 1720s and 1730s British foreign policy was to avoid war. When in the 1740s and mid-1750s this policy was sporadically reversed, the taste of victory became no less familiar than that of defeat. Equally, despite the significant growth of Britain as importer and exporter of bulk goods, indigenous producers in virtually every luxury trade and art during the period 1710–50 lived with the expectation that the workmanship of foreigners would be preferred to their own.[18]

British trade law was generally slanted towards the preservation of a liberal commercial environment. The sheer number of foreigners who practised luxury trades and arts in Britain is itself indicative of the absence of practical inhibitions upon their activities. Evidence that many seem to have left the country with great capital sums indicates that there was little impediment on them removing assets from the national economy. It fell to persons engaged in commerce to involve themselves in private initiatives, from nationalist clubs to newspaper lobbying, in order to promote indigenous production. In this soci-

23 O The Roast Beef of Old England ('The Gate of Calais') 1748 Oil on canvas 78.8 × 94.5 (31 × 37¼) Tate

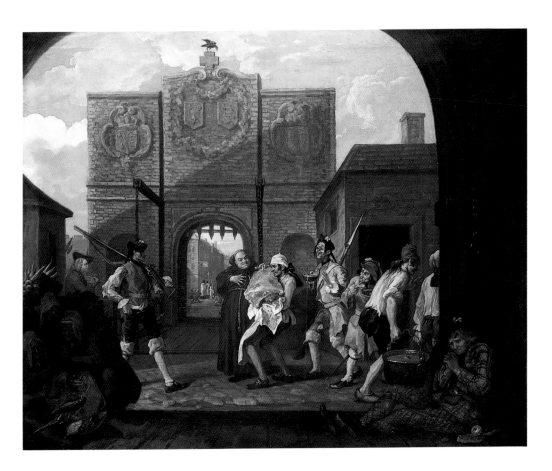

ety of 'liberty' the battle to survive foreign competition took place more in the sphere of public opinion than that of public legislation. Hogarth, it may be argued, simply had the intelligence to realise this and the skill to prosecute a role of influence to great effect.

Hogarth's desire to create forms of art that were suitable for Britons was, as we have seen, much dependent on a Protestant sense of the necessity for social reform. In the field of the visual arts the spirit of reform was traditionally associated with some sort of 'renaissance', a revival or return to commendable basics. Hogarth was faced with the problem that a British painter of his generation had no indigenous tradition to revive. In so far as widely admired art had been produced in Britain, it was largely by foreigners such as Holbein (1497–1543) and Van Dyck (1599–1641). These painters largely serviced the demand for portraiture, the national vanity that Hogarth affected to despise. The logic of Hogarth's circumstances was that if he wished to instigate a reform he would have to invent rather than revive.

In early and mid-eighteenth-century England the notion of 'invention' largely meant the witty adaptation of a surviving concept or tradition. Hogarth seems to have acted upon the principle that there already was a national tradition to adapt, the tradition of literature and the stage. Eighteenth-century commentators reflecting upon Britain's lack of a great heritage of visual arts frequently referred to the contrast with the country's proud literary and theatrical tradition.[19] A pessimistic response to this problem, one made by a number of mid-eighteenth-century foreign observers, was that Britons were temperamentally predisposed to be a people of the word rather than the image. For those lobbying for the improvement of the British visual arts this explanation could be discounted as one that imposed a pre-ordained limitation on all their ambitions. Hogarth, ever positive about national ambitions if not the national *status quo*, appears to have proceeded from the understanding that national greatness in the field of the visual arts would be most swiftly attained by drawing on pre-existing literary and theatrical tradition.

The idea that Hogarth founded his art on a British literary and theatrical basis was most obviously expressed in his famous engraved self-portrait with his pug dog 'Trump' of 1745 (fig.24). Here we see Hogarth's oval portrait, a painting within a painting, propped up on copies of Shakespeare, Swift and Milton. By presenting himself to posterity in this way Hogarth contributed to the process whereby he passed into history as a writer who communicated through the painted image. Throughout his career his art conveyed a fundamental desire to emulate the effects of the stage and novelistic narrative. He artfully set out to demolish the precept, which had its earliest expression in classical sources, that painting was necessarily inferior to the poetic arts owing to the limitation of its narrative to a single moment of time.

Hogarth's 'invention' of the print series, where one act is seen to have its consequences in the next, is merely the most obvious sign of his desire to embark upon a conquest of the dimension of time. From portraits to narrative prints his work abounds with details that suggest what is about to happen as well as what is happening: buildings are on the verge of collapse, people are

24 *The Painter and his Pug* 1745
Oil on canvas
90 × 69.9
(35½ × 27½)
Tate

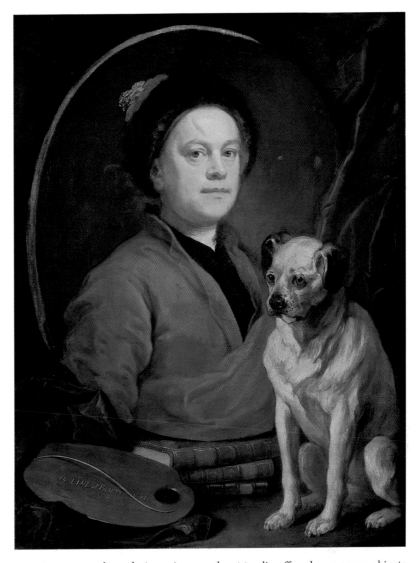

tottering on toppling chairs, wigs are about to slip off and numerous objects
are on the point of catching fire. Equally, Hogarth invented a masterly means
of communicating the past through the state of people and things in the pre-
sent. Those with a sharp eye for the signs of physical disease, for instance,
could see myriad indications of past habits and vices upon the bodies of his
characters. The *Marriage A-la-Mode* series proliferates with such imagery. In
the first print the gouty foot of the seated lord indicates a family fortune dissi-
pated through luxurious living, while a patch on the neck of his son, Viscount
Squanderfield, can be taken to hide the sore of some congenital disease or
venereal condition (fig.25).

Much as Hogarth could be relied on not to play down the greatness of his
innovations, it is hardly a surprise to read in his biographical anecdotes that
he believed he had struck on a means not only of competing with the narra-
tive drive of literature but also of exceeding it. In his hands, he claims, paint-

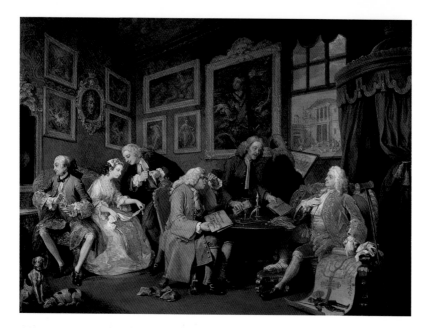

25 *Marriage A-la-Mode: 1. The Marriage Settlement*
1743
Oil on canvas
90.8 × 69.9
(27 × 35)
National Gallery, London

ing had been made to communicate narrative with more economy than the written word:

> In these compositions, those subjects that will both entertain and improve the mind, bid fair to be of the greatest public utility, and must therefore be entitled to rank in the highest class ... Ocular demonstration will carry more conviction to the mind of a sensible man, than all he would find in a thousand volumes; and this has been attempted in the prints I have composed. Let the decision be left to every unprejudiced eye; let the figures in either pictures or prints be considered as players dressed either for the sublime, or farce, – for high or low life. I have endeavoured to treat my subjects as a dramatic writer; my picture is my stage, and men and women my players, who by means of certain actions and gestures, are to exhibit a dumb show.[20]

Here Hogarth challenges not only the conventional idea that the word was more instructive than the image but also the opinion of those who ranked tragedy as more instructive than comedy. He justifies a career devoted largely to his comic talents with the argument that, if painting should be valued by its public utility, then comedy deserves the highest rank, for it sweetens the pill of moral instruction with entertainment.

Following Shakespeare's model, Hogarth sought in the 1740s and 1750s to move from the comic or tragic form. Only public disapproval of his attempts in the latter sphere limited his conviction that his abilities were equal to the example of 'the bard'. The inclusion of the name of Swift among those whose volumes support his famous self-portrait can be taken as a recognition that Hogarth was proud to be associated with the comic tradition of English litera-

ture. The choice of Swift, however, indicates something more specific than the national heritage of comedy.[21] Swift was famous as a biting satirist, a scourge to the follies of state rather than fond critic of human foibles. As he stated in an essay printed in the *Examiner*, Swift regarded satire as a means of publicly shaming those who had lost all sense of private conscience. He claimed that satire had been introduced into the world, 'whereby those whom neither religion, nor natural virtue, nor fear of punishment, were able to keep within the bounds of their duty, might be upheld by having their crimes exposed to open view in the strongest colours, and themselves rendered odious to mankind'.[22]

Hogarth's inclusion of his pug dog in his self-portrait further emphasises his desire to associate himself with the idea of biting satire. A pamphlet penned by a supporter of Hogarth purporting to feature the conversations of this pug records the dog's acknowledgement that it is nothing more than 'a little, pert snarling animal'. This quotation is reminiscent of a humorous seventeenth-century British definition of 'satire': 'Girding, biting, snarling, scourging, jerking, lashing, smarting, rough, invective, censorious, currish, snappish, captious, barking.'[23]

It is often assumed that Hogarth's pug was a British breed and signifies British pugnaciousness. The aforementioned pamphlet, however, explicitly refers to the dog as a 'Dutch Pug'.[24] It was, indeed, commonly thought that this type of dog had first become popular in Holland and had begun to appeal to the English at about the time of the arrival of the Prince of Orange in 1688. Far from being a thoroughbred, the pug is defined in most near-contemporary sources as a class of 'mongrel', it being a cross of uncertain foreign breeds with the British bulldog.[25] Later in the century Thomas Bewick in his *A General History of Quadrupeds* was to observe humorously that no dog 'affords more doubts as to its origins' than the pug.[26] Hogarth's close identification with the pug may well reflect his awareness of Defoe's famous statement in his humorous verse satire *The True-Born Englishman*, that the English drew their greatness from being a 'mongrel half-breed race' formed of every sort of blood.

Hogarth's choice of a pug as his personal emblem may also reflect his awareness of his insignificant origins and cheeky social persona. *The Sportsman's Cabinet*, a book on breeds of dog popular in England, described the pug thus:

> in the whole catalogue of the canine species there is none of less
> utility, or possessing less powers of attraction than the pug-dog ...
> applicable to no sport, appropriated to no useful purpose, susceptible
> to no predominant passion, and in no way remarkable for any extra
> eminence, he has continued from age to age in the role for which he
> might have been originally intended, the patient follower of the
> ruminating philosopher, the adulatory and consoling companion of
> an old maid.

The figure of a brave little animal that triumphed against its own utter insignificance was a fitting emblem for a man who did not let his humble birth or small physical stature prevent him taking on the foibles of the world.

Through the figure of this pug Hogarth lampooned the whole continental tradition of posing 'great' men and women with high-flown emblematic figures signifying the character of their genius. This canine attendant constituted a joke at the expense of the classical concept of the muse. In the pamphlet where he is given a voice Hogarth's pug addresses his adversaries thus:

> know that, howbeit to all outward appearance I may appear nothing more than you would call a Pug, yet within this canine form an heavenly emanation dwells, the genius that inspired Hogarth in all his performances, for which in grateful return, he has so often rejoiced in my celestial and perishing appearance; Mohammed had his pigeon, Hogarth has his pug.[27]

Although Hogarth's habit of posing himself with Trump can be seen as a parody of the grandiose bluster of rank and genius that he associated with foreigners, it can also be interpreted as a self-parody. Hogarth must have been aware that he was notorious for being a self-important and presuming individual who aspired to a role of social leadership that defied his humble origins. It would appear that he justified his own ambitions for social consequence by the exercise of his gift for self-parody, which focused on a ritualistic recognition of his 'mongrel' lack of significance. For the Briton, it would seem, ambition was acceptable if it was offset by the ability to stand back from the self-promoting drama of one's own life and laugh at oneself.

This association of the concept of the detached eye of the humorist with national virtue may be understood in the context of a broader debate on the relationship of independence and patriotism. 'Independence' was one of the key concepts of electoral politics in Britain during the early and mid-eighteenth century. Civic bodies formed at the time of the London elections, such as the oppositionist 'Free and Independent Electors of Westminster', were particularly inclined to regard the citizen's independence from party as a primary patriotic duty. It is part of the complexity of period political rhetoric that the claim to 'independence' became a mere party slogan. In the Walpole period the very word 'patriot', which came to imply freedom from party prejudice, was appropriated by opposition factions and, in retaliation, became a key word in government propaganda. Continually accused of promoting party interest and private ambition, Robert Walpole resorted to the claim that he was a 'patriot statesman' threatened by the envy and spite of self-interested opponents.

Any discussion of Hogarth's 'nationalism' must feature an analysis of how the formation of his public identity relates to the complex contemporary debate on the nature of 'the patriot'.[28] In the past twenty years it has been fashionable to assume that, during the Walpole period, Hogarth's fervour for his country aligned him with the ideology of the 'patriot' opposition. Recently, however, some scholars, most conspicuously David Bindman, have questioned this assumption.[29] Bindman rightly pointed out that Hogarth's father-in-law James Thornhill was, by and large, a loyal whig supporter of Walpole. Hogarth, indeed, produced a print showing Thornhill in the proud company of Walpole and an assortment of the leading members of his admin-

istration. It is a measure of the complexity of this problem, however, that there were occasions when Hogarth's art was used in the cause of opposition propaganda. It would seem, for instance, that his friendship with Jonathan Tyers, the manager of Vauxhall pleasure gardens, drew Hogarth into opposition circles. Tyers managed the gardens by grace of Frederick Prince of Wales, who had effective ownership over much of the land. When Frederick, aiming to define himself as a 'patriot' prince, set up a rival court to embarrass his father and mother and their favourite Robert Walpole, it was natural that Tyers should be drawn into opposition. It is probable that Tyers commissioned Hogarth to paint a large canvas, which was exhibited near the entrance gate of the gardens, on the theme of the autocratic Henry VIII, Anne Boleyn and their scheming statesman Wolsey, to parody the relationship of George II, Queen Caroline and Walpole.

Hogarth could not have been ignorant of the ramifications of his satire. However, it must be remembered he was probably producing an image at the behest of others. His authorship of this satire is a scant basis on which to found a case that he had sustained oppositionist loyalties. Throughout the 1730s, at the peak of the opposition to Walpole, Hogarth seems to have been as happy in the company of government loyalists as prominent dissidents. At the end of this period he painted a fine conversation piece of the government group, including Thomas Winnington, Stephen Fox and Lord Hervey, who

effectively sustained Walpole in power through the final period of crisis that was eventually to unseat the prime minister (fig.26). The group seem to be enjoying an afternoon of wine and abundant rural fun before a statue of Britannia. It is difficult to conclude from the air of the painting that Hogarth was anything other than comfortable in this political company.

Hogarth's association with various political circles can be regarded as a sign of his high-minded patriotic independence. Equally, it is reasonable to conclude that such a shrewd businessman saw little point in reducing his potential market by becoming too closely identified with a faction. Hogarth must be distinguished from such instruments of party propaganda as George Bickham, a skilled engraver who appears to have attached his colours firmly to the mast of Walpole's opponents (fig.27). Hogarth shunned the role of political satirist in favour of the higher realm of social satire, avoiding the sort of 'low' personal invective that characterised the work of graphic satirists who fuelled the great party disputes of the day.[30] Indeed, there is evidence that he saw an involvement in party politics as a serious threat to personal integrity. At the height of the opposition to Walpole he produced a print parodying the coffee house politician whose involvement with the trivia of party is depicted as a form of moral and patriotic myopia. So intense is the politician's concentration upon some newspaper dispute that he fails to notice that his candle is about to set his own head alight.

27 George Bickham Junior
The Late Prime Minister 1743
Engraving
30.5 × 24.1
(12 × 9½)
The British Museum

Towards the end of his career, suffering from a protracted illness, Hogarth appears to have fallen into the trap of neglecting his own sage advice on matters of politics. Perhaps because he was old and rich enough to afford the luxury of risking the alienation of a part of his potential public, he came out in favour of a party cause and allied himself with the supporters of the Earl of Bute, the favourite of the young king George III. He produced a satirical print, *The Times* (published September 1762), which constituted an explicit attack on the war-mongering foreign policy of Bute's rival, William Pitt. It is, perhaps, the strongest indication that Hogarth had remained politically independent throughout his career that this move was recognised by contemporaries as a shift away from his customary practice. The circumstances that caused him to change the habits of a lifetime are part of the subject of the next chapter.

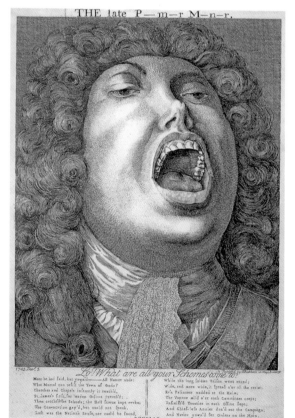

4

LIBERTY AND LIBERTINISM

In recent years it has become fashionable for historians to describe the dominant cultural experience of early and mid-eighteenth-century Britain as 'the rise of a polite society'.[1] At the core of this ideal was the belief that social harmony could be achieved through the inculcation of agreeable manners and a sense of civic duty. This was not a courtly ideal of manners, though its roots were in courtly conduct. Rather it was a mode of behaviour which was recommended to the 'middling sort' and above. This sector of society defined itself as a 'public' on the basis of its politeness, it being understood that the unrefined populace, who in times of civic disturbance formed 'the mob', could be distinguished from them by their lack of agreeable refinements.

Mid-eighteenth-century British 'politeness' was, generally speaking, anything other than a code of stiff mannered behaviour or strict and pleasureless moral observance. It was a public cult centred on values of the control of man's appetite for pleasure, not its complete subjugation. As Dr Trusler, a notable commentator on Hogarth, suggested in his conduct manual, *The Principles of Politeness*, the ideal of politeness revolved around the notion of pleasure in moderation:

> Few men can be men of pleasure; every man may be a rake. There is a
> certain dignity that should be preserved in all our pleasures; in love a
> man may loose his heart without loosing his nose; at table a man may
> have a distinguished palate without being a glutton; he may love wine
> without being a drunkard; he may game without being a gambler;
> and so on. Every virtue has its kindred vice and every pleasure its
> neighboring disgrace. Temperance and moderation make the
> gentleman; but excess the blackguard.[2]

Hogarth's moral agenda has been described, with good cause, as the dissemination of polite values.[3] Although in some respects a character of extremes, he was a figure much preoccupied with marking the boundaries that distinguished social pleasures from destructive excesses. His imagery constantly returned to the moments where these boundaries were infringed. All these moments of transgression can be seen to constitute the decline of the liberty to pursue happiness and prosperity into libertinism or 'licence'.

Hogarth's *oeuvre* immediately brings to mind the concept of libertinism. Indeed, a recent book that dwells on the social history of the British libertine in this period is entirely illustrated by Hogarth's works.[4] This is not simply because Hogarth's moral agenda seems so frequently to be the exposure of the typical social territory of libertinism – whoring, rakishness, illegitimacy, marital inconstancy, homosexuality and venereal disease – but also because he

28 *A Midnight Modern Conversation* 1732
Etching and engraving
34.1 × 46.8
(13⅜ × 18⅜)
The British Museum

himself does not appear to have been able to resist the company of some of the nation's best known libertines, most notably Charles Churchill, John Wilkes and Francis Dashwood.

Despite the fact that Hogarth's prints took on the classic causes embraced by groups formed with the express purpose of opposing the culture of libertinism, societies for the 'reformation of manners', his own conduct occasionally drew upon the classic libertine repertoire. A tendency towards violent anti-Catholicism and anti-clericalism seems to have spilled over into the realms of blasphemy, a favourite taboo for libertines to violate. An anecdote relating to an impromptu trip into the suburban countryside with a group of friends during the 1730s records how he entertained the group by shitting upon a grave and, when ceremoniously castigated, finishing off on the church door.[5] This sort of behaviour mimicked that which is recorded of London's libertine gangs who showed their contempt for respectability by such acts as pissing in pulpits.[6]

Hogarth's sacrilegious proclivities attracted him to one of the most notorious libertine clubs of the day, Francis Dashwood's 'Monks of Medmenham'.[7] This jocular group conducted impious rituals on the site of an Augustine Priory at West Wycombe in Buckinghamshire. Hogarth contributed to the riotous fun of this group by painting its founder, Francis Dashwood, in the guise of a hermit saint contemplating, in place of a crucifix and skull, a reclining naked woman and a heap of food and wine. Hogarth's taste for the occasional binge in the company of men is further witnessed in two group portraits of drinking parties, known as *A Night Encounter* (c.1738) and *Charity in the Cellar* (c.1739). While Hogarth's self-portrait does not feature in the works, they hardly encourage the impression that he was a sober or disapproving bystander.

These works resemble his print, made during the 'excise crisis' of 1733–4, depicting *A Midnight Modern Conversation* (fig.28). This print which shows a group of men, possibly symbolic of the country at large, drinking themselves to stupefaction as the nation argued about the politics of taxation on such things as alcoholic drinks. Although it is possible to interpret this print as a straightforward attack on drunken excess, one suspects that Hogarth's satire

of this vice is both indulgent and somewhat ambivalent. Hogarth's intent was, probably, to expose the way in which some 'modern' gentlemen interpreted the notion that drink could form the essential lubricant of the polite art of 'conversation'. This notion was propounded in conduct manuals such as *The Young Gentleman and Lady Instructed* which advised that alcoholic drink 'disperses melancholy' and 'restores the whole man to himself and his friends without the least pain or indisposition ... it heightens conversation and brings to light agreeable talents, which otherwise, under the oppression of unjust modesty, would have lain concealed.'[8] Hogarth's scene clearly does not show a 'modern' world in which drink functions to expose men's 'agreeable talents'. One suspects, however, that this image is but the mildest of satires upon the vice of binge drinking and intends to urge toleration of a shared transgression. Hogarth's title, *A Midnight Modern Conversation*, may even suggest a certain impatience with the unrealistic expectations of those who promoted ideals of elegant civility in masculine company.

That Hogarth seems to have tolerated, or even enjoyed, the tendency of men to take inebriated breaks from the restraints of polite society does not justify the supposition, which runs through the commentaries of his contemporary critics, that he was below all claims to politeness. He lived in a society in which a high proportion of medical cures were purgative. To binge and occasionally vomit were neither necessarily harmful to the individual body nor damaging to the general moral interests of the polite body politic. Hogarth was, however, a firm opponent of habitual drunkenness. Drink seems to have a role in all his calamitous 'Progresses'. In the *Rake's Progress*, for instance, he makes clear that habitual drunkenness constitutes the first stage of the loss of rational control that eventually leaves a man a raving lunatic on the cold floor of Bedlam, London's principal lunatic asylum (figs.29, 30).[9] For Hogarth alcoholic licence is but a step to lunacy. In general, the role of vices in causing persons to 'lose the plot' of life, to use a modern colloquial phrase, is what appears to be Hogarth's chief concern.

While Hogarth's attitude to drink was somewhat complex and difficult to fathom, his attitude to the vice of gambling was consistently and unambigu-

Below left
29 *A Rake's Progress*, Plate 3 1735
Etching and engraving
35.5 × 40.8
(14 × 16)
The British Museum

Below right
30 *A Rake's Progress*, Plate 8 1735
Etching and engraving
35.5 × 40.8
(14 × 16)
The British Museum

ously disapproving. A preoccupation with the error of placing life in the hands of fortune spanned his entire career. His earliest satirical prints were attacks on public lotteries and the financial speculations of the City. His last great success was a fine depiction of *The Lady's Last Stake*, an image of a fashionable woman who has betted away all of her material possessions and is left only with her sexual virtue to offer to a predatory male (fig. 31).

There are numerous ways of explaining this preoccupation. Some years ago the scholar David Dabydeen advanced a thesis that the shock of the bursting of the notorious South Sea Bubble, which occurred in 1720, cast a shadow over Hogarth's whole career.[10] This event, the period's greatest stock market collapse, undoubtedly alerted persons to the possibility that national commercial and political life could be turned into little more than a massive betting bonanza.[11] In this vision it was possible to see the private gambler as no more than a component in a state that lurched from crisis to crisis on a sea of fortune. Clearly, Hogarth's early satire on the South Sea Scheme (1721) does suggest that such thinking did occur to him (fig. 32). His enduring concern with the perceived abuses of commercial freedom, in particular the purchase

31 *The Lady's Last Stake* (also known as *Piquet, or Virtue in Danger*) 1758–9
Oil on canvas
91.4 × 105.4
(36 × 41½)
Albright-Knox Art Gallery, Buffalo, New York

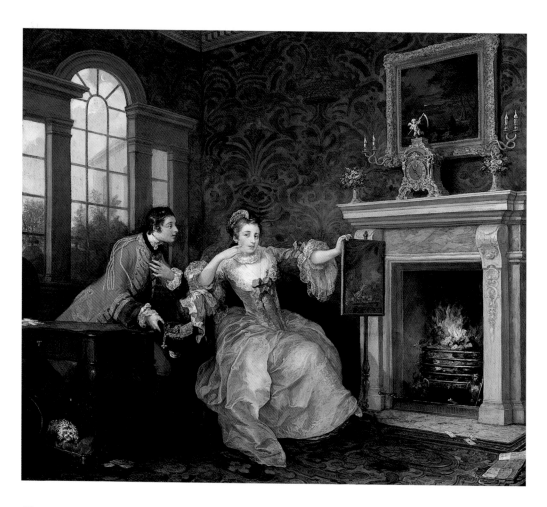

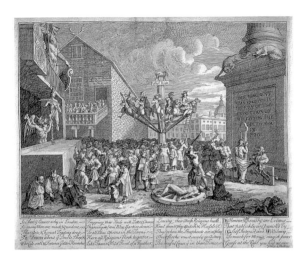

32 *The South Sea Scheme* 1721
Etching and engraving
21.6 × 24.8
(8½ × 9¾)
The British Museum

of corrupting foreign luxuries, may be connected to a more general belief that the entrepreneurial character of British society was in constant danger of degrading into a culture of mindless commercial excess.

Dabydeen's thesis is, however, flawed by a tendency to overlook the possible religious dimensions to Hogarth's concern with the culture of risk. In fact, Hogarth's attitude to this subject cannot be understood without reference to the contemporary theological debate on the nature of 'providence'. Having a faith in providence – in the understanding of numerous Latitudinarian[12] preachers of this period – was something to be sharply defined from merely placing oneself in the hands of fortune.[13] Belief in providence focused on the conviction that, whatever the apparent setbacks of life, a virtuous spirit would prevail and have its rewards. A good God, it was supposed, could only have reward for those who behaved according to the dictates of a Christian conscience. Those who trusted in fortune, by contrast, hoped for the favour of a goddess dear to pagan superstition, blind Fortuna. Fortuna was construed to require no moral system, for she rewarded and ruined without respect to man's worth or deserts. Hers was seen as a world of chaos. Those who placed their trust in her courted disaster. The general implication of this theology was that the person or society who lived by gambling showed a contempt for providential order and neglected to trust in the beneficence of God.

Hogarth was no stranger to such theology. His close friend and supporter, the novelist Henry Fielding, was the greatest literary proponent of providential order. The narrative of Fielding's *Tom Jones* (published 1749), for instance, is clearly a witty allegory of providence. The young foundling Tom Jones retains a generous heart, and this, despite reverses due to a weakness for indulging the pleasures that came his way, eventually has its own reward. His benign father, who exhibits some of the attributes of an indulgent God the Father, eventually rewards him in accordance with the worth of his intentions. Hogarth's prints on the theme of the Industrious and Idle Apprentices can also be interpreted as lessons on a theme of providence. Dr Trusler was, indeed, quick to realise this sub-plot. He observed that the prints illustrated

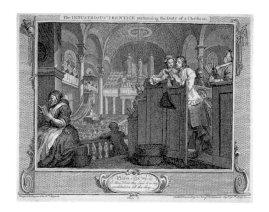

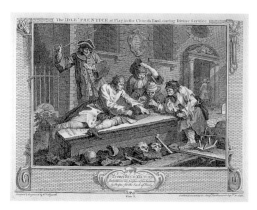

the manner in which 'the obstinate and incorrigible shut their ears against the alarming call of providence, and sin away the possibility of salvation'.[14] The second stage of this narrative, the first contrasting pair of scenes, presents Goodchild at Sunday worship while Tom Idle, outside in the churchyard, plays a game of chance with some other idle fellows (figs.33, 34). Goodchild has chosen to put his trust in providence and a course of life. Tom Idle has put his trust in fortune and a course of death. It is significant that his gaming table is the tilting capstone of a table tomb, the tilt of the tomb leading inexorably into an open grave. In the next scene we discover Tom Idle gambling his future on the adventures of seafaring (fig.35). The rough sea on which his frail rowing boat is tossed signifies his choice to place his life in the hands of a chaotic element. The notion of life as a mere adventure where people allow themselves to be tossed from one circumstance to another permeates the narrative of Tom Idle. It is significant that the first scene of the series shows a copy of Defoe's *Moll Flanders* on Tom's loom. This book was probably chosen not only to indicate Tom's taste for risqué literature but also because it was a narrative about a woman who lives by chance. Defoe's Moll was the ultimate female adventurer who risks ruin at every turn and Tom appears to be her disciple.

Above left
33 *The Industrious 'Prentice performing the Duty of a Christian* 1747
Etching and engraving
26.5 × 35
(10⅜ × 13¾)
The British Museum

Above right
34 *The Idle 'Prentice at Play in the Yard during Divine Service* 1747
Etching and engraving
26.5 × 35
(10⅜ × 13¾)
The British Museum

35 *The Idle Apprentice Turned Away and Sent to Sea* 1747
Etching and engraving
26.5 × 35
(10⅜ × 13¾)
The British Museum

Throughout the series Goodchild seeks out clean and ordered environments, while his anti-type moves in a world of dirt and collapse. The execution of Tom Idle, amid the aggressive chaotic mob of Tyburn, is seen as the reward of a dissolute pursuit of mere chance. Conversely, the eventual material success of Goodchild can be interpreted as the reward of placing one's faith in the order of providence. Goodchild, who clearly makes his money through honest commerce, serves as an example to others that venturesome pursuit of wealth need not spill over into damaging speculation. He represents the acceptable ideal of the City of London that had, in its darker moments, visited the South Sea crisis on British society.

Betting plays a role in many of Hogarth's scenes depicting the 'progress' of individuals towards disaster. The second scene of the *Rake's Progress*, for instance, shows Rakewell in the company of jockeys and committed to the thrills of the turf. A crude picture of a cockerel on the wall behind suggests that he has developed a taste for betting on cockfights. The second scene of the *Harlot's Progress* centres on a more subtle image of chance (fig.2). The Harlot, who has fallen under the protection of a wealthy Jew, is seen at the moment of purposefully overturning a table with coffee cups. Her aim is to distract the Jew's attention from her young lover who is being ushered from the room by a co-operative maid. By creating an accident, the Harlot signifies that she puts her trust in the effects of disorder. She is patently accustomed to taking enormous risks in life and feels that she can manipulate chance, or accident, in her own favour.

The Harlot's appetite for risk cannot be purged by the punishment of beating flax at Bridewell, a house of correction for London prostitutes. Observant viewers may spot a tattered playing card on the floor, a sign of surreptitious betting and witness to Hogarth's pessimistic conviction that some prostitutes will not be persuaded to quit their reliance on blind fortune (fig.4). This image reminds us that mid-eighteenth-century moral critics tended to be harder on the woman who came to enjoy the thrills of chance than her male equivalents. *The Young Gentleman and Lady Instructed*, for instance, reserved its highest contempt for the 'female gamster' and 'female adventures'.[15] The author explained that women, then conventionally considered to have weaker rational powers than men, were thought particularly prone to staking their fate on such things as the turn of a piece of 'spotted paper'.

Hogarth's antipathy to betting finds particular expression in his engraving of *The Cockpit* (fig.36). Details in the image, specifically the presence of 'Jackson', a famous hunchback jockey, hint that the location is Newmarket racecourse. We have here, therefore, an image of how one superficially mild vice degrades into a serious vice of cruelty; those attracted to watch horses race are drawn by the prospect of a bet to observe birds fight to the death. The point of the print is to illustrate the manner in which the spectacle of exciting cruelty, united with the thrill of gambling, brings all society down to the lowest common denominator. In one commentator's opinion the focus of the print was on the moment 'when the carpenter's paw mauls the titled ribband'. He observed that the scene shows how 'these unfeeling savages of the cockpit, form a heterogeneous group of Peers and pick-pockets, jockeys and butchers,

36 *The Cockpit* 1759
Etching and
engraving
30.2 × 37.8
(11⅞ × 14⅞)
The British Museum

chimney sweepers and gentlemen'.[16] Hogarth's point in this print is, surely, to
hit on a modern means of illustrating the ancient concept of 'blind fortune'.
At the centre of the image he placed the figure of a blind aristocrat, said to be
a portrait of Lord Albemarle Bertie, staking his fortune on a risk he cannot
even see. All around him are figures who appear to exhibit a degree of blind-
ness. In the foreground, for instance, two figures already close to the action try
to get a closer view of the form with the aid of telescopes. Their lenses point at
each other, rendering them blind. Hogarth alerts his viewers to the natural
connection between trusting in blind fortune and social chaos, the loss of
common bonds of human sympathy and all sense of appropriate social hier-
archy.

Hogarth, particularly in the late 1740s and 1750s, was a man much con-
cerned with the tendency of the people towards chaos and riot, a manifesta-
tion of the permeation of moral licence into the very foundation of society. It
is impossible to dissociate these concerns from his preoccupation with nation-
al character. The disorder of British streets could be regarded as a physical
manifestation of the national proclivity towards liberty. One reviewer, com-
menting on scenes of riot in the *Election* series, quoted a contemporary letter
from a proud Englishman to a friend in France: 'It is worth your while to come
to England, were it only to see an election and a cock match. There is a celes-
tial spirit of anarchy and enthusiasm in such scenes that words cannot paint
and of which no countryman of yours can form an idea.'[17] The implication of
this passage is that Englishmen's appetite for 'anarchy and enthusiasm' dis-
tinguishes them from the citizens of more authoritarian states such as France.
Whatever the apparent barbarity of such scenes, they illustrate a privilege of
belonging to a state that does not regiment its citizens.

Hogarth cannot be too closely associated with such views. It is plain that he
found cockfights and election riots to be a sign of the breakdown of the moral
fabric of the nation. He was, however, not averse to regarding the challenging
disorder of the English crowd, infuriating and disreputable as it was, as some-
thing of which to be proud. A classic expression of this idea was his enter-

taining image of *The Enraged Musician* (fig. 37). In this work Hogarth depicts the frustrations of a foreign violin virtuoso, said to be a portrait of Monsieur Cervetti,[18] attempting to practise in a London street crowded with hawkers, a knife grinder and a host of noisy children. The idea of the print is taken from a late seventeenth-century set of engravings by Marcellus Laroon on the theme of *The Cryes of London* (fig. 38).[19] The central character, the beautiful milk girl carrying metal vessels on her head, is adapted directly from Laroon. Hogarth borrows from his source the general idea that the noisiness of London's streets was an endearing part of their character. It is significant that the one character who cannot appreciate this mayhem is a foreigner, a man who, like the recipient of the letter quoted by Trusler, is not culturally disposed to appreciate the 'anarchy' of the national spirit.

A more complex response to the association between disorder and national character may be found in Hogarth's great image of *The March to Finchley* (fig. 39). This work celebrates a fictive occasion when British troops are seen to congregate between two inns in preparation to march out and suppress the Jacobite Rebellion of 1745. The general theme of the work is the disorder and drunkenness of His Majesty's troops. These failings did not limit the effectiveness of British soldiers, for, as the viewer would have been aware, they successfully destroyed their Jacobite opponents. Hogarth was, indeed, presenting the national disinclination towards military discipline as a weakness to be indulged.[20] Ultimately, he suggests, British soldiers could be relied on, despite their liking for the occasional drinking bout and loose women. In composing this image Hogarth may have had in mind the idea of subverting a humourless patriotic print of the day which, through showing militia troops marching north in ordered rank, perpetrated the phoney propaganda legend that the British army was a tightly disciplined force (fig. 40).

As a passionate proponent of national liberties, Hogarth may well have

Below left
37 *The Enraged Musician* 1741
Etching and engraving
35.7 × 41.2
(14 × 16¼)
The British Museum

Below right
38 M. Laroon
The Merry Milk Maid (from *The Cryes of London Drawne after Life*) 1687
Engraving
27 × 16.1
(10⅝ × 6¼)
The British Museum

been disconcerted by suggestions in the press that the Jacobite rebellion should act as a stimulus to the transformation of Britain into an ordered military society. Typical of these was a call in the *London Magazine* of May 1746 for the application of a strict code of military discipline, which began: 'Altho' the Rebellion is now in great measure suppressed, yet I hope that the warlike spirit and desire to learn military discipline, which with providence seems to have inspired all ranks of men on that occasion, will no way subside.'[21] Hogarth communicated his resistance to such attempts to turn Britain into a military state through an inscription at the base of his *March to Finchley*. This took the form of a mock dedication to 'His Majesty the King of Prussia, an encourager of arts and sciences'. Hogarth's intention was to show Britons that imitating Prussian military discipline would lead to the end of polite civilisation. His tribute to Prussian arts and sciences was, of course, a sarcastic joke, the militarism of that state being strongly associated with philistinism.

Hogarth hinted that Britons had no need of this sort of regimentation. They could have confidence in the loyalty and effectiveness of national troops, despite their dissolution and the impression that they lacked patriotic resolve. Hogarth's joke on the disparity between the realities of army life and the rhetoric of militarism was not to everybody's tastes. It passed beyond the limited intelligence of the supreme commander of these troops, the Duke of Cumberland, who is reported to have found the print deeply offensive.

39 *The March to Finchley* 1750
Oil on canvas
101.5 × 133
(40 × 52½)
Coram Foundation,
London, UK

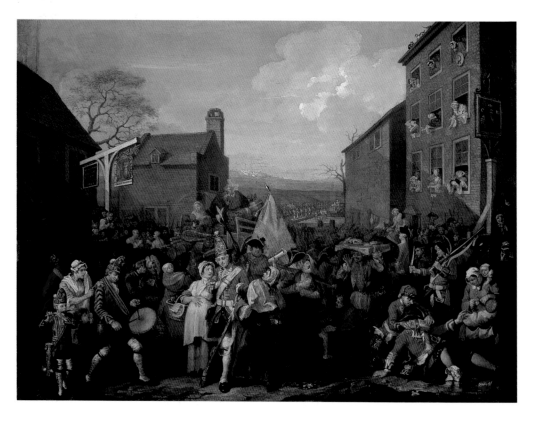

40 Anon
The Loyal Associators
Etching and
engraving
20.3 × 17.8 (8 × 7)
The British Museum

While Hogarth's distrust of state authoritarianism led him to indulge disorder in the army, he was less tolerant of states of disorder that encouraged the unruly populace in the supposition that they had the power to dictate the tone of public and political affairs. Hogarth's fear that the timbre of political life was being set by the violent and disordered populace led to the most important public dispute of his later life. This argument surrounded his decision publicly to attack the war-like foreign policy of William Pitt and support the political cause of the conservative court governance of Lord Bute, the favourite of the newly crowned George III. This attack came in the form of a print entitled *The Times* (fig.41).

Hogarth's fear, as he explained in his biographical memoirs, was that the Pitt party had become reliant upon stirring up the base aggressions of the crowd. He described his print of *The Times* as: 'A subject tended to the restoration of peace and unanimity, and put the opposers of these humane objects in a light, which gave offence to those who were trying to foment disaffections in the minds of the populace.'[22] In making this assertion he had a reasonable case. Long years in opposition had taught Pitt and his allies that the support of the patriotic urban masses could become an important route to political power. Pitt discovered that urban commercial society could be relied upon to support policies of imperial aggression on the understanding that territorial gains would promote the scope of trade. By contrast, the landed interest, always nervous of the effects of war taxes on their revenues, were always likely to lose faith in protracted military ventures. It was in Pitt's interests to present himself as a statesman of the people and aim his party propaganda at inflaming the nationalistic passions of the urban commercial classes.[23]

The individual most responsible for communicating Pitt's political policies to this constituency was the maverick journalist John Wilkes, a friend of

Hogarth and one of Francis Dashwood's 'Monks of Medmenham'. In choosing to oppose Pitt in public, Hogarth was seen to betray his friendship with the statesman's prominent supporters and his concern for popular liberties. He was consequently strongly attacked in the press. Hogarth's response to these broadsides was hastily to produce a satirical portrait of Wilkes (fig.42) which he sold as a pair with a graphic portrait of Lord Lovat, a chief conspirator in the Jacobite Rebellion of 1745, which he had produced some years before. The implication of the pairing was, of course, that Wilkes was no more than a traitor.

Wilkes's libertine ways – he was known to have been the author of a scandalous pamphlet on the female sex – delivered him into Hogarth's hands as an object of satire. He presented him with the thin angular physique familiar in his figure of Rakewell. A leering, cross-eyed visage hints at a dissolute and lecherous mind. In Wilkes's hand Hogarth placed a device somewhat similar

Below left
41 *The Times*, Plate I, 1762
Etching and engraving
22 × 29.5
(8⅝ × 11⅝)
The British Museum

Below right
42 *John Wilkes* 1763
Etching, First State
31.8 × 22.2
(12½ × 8¾)
The British Museum

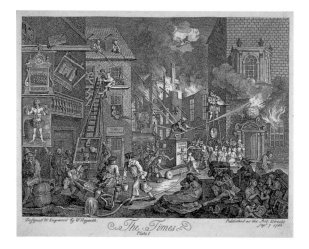

Left
43 Michael Rysbrack
Monument to Watkin Williams Wynn 1754
Marble
Conway Library, Courtauld Institute of Art

to the pole and Phrygian cap seen in standard emblematic personifications of 'Liberty' (fig.43). It would appear, however, that this cap was replaced with some sort of bowl, a cross between a punch bowl and a piss pot. The suggestion was that Wilkes's posturing as a champion of liberty was not enough to disguise the fact that he was merely a libertine. The substitution of the classical female figure of Liberty with a scrawny street character formed a witty commentary on the debasement of ancient ideals through the vulgarisation of modern urban politics.

Hogarth's contempt for such debasement of political affairs had already been expressed in his *Election* series of 1753–4. Here a typical British mob is seen to exploit the privilege of their political freedoms to indulge their violent and debauched tendencies. Hogarth most explicitly confronts the theme of the distinction between liberty and licence in the first image of this series (fig.44). The scene is an election meal organised by the Whig party who are recognised by their orange rosettes. All around the table potential voters gorge themselves at the expense of those who are attempting to buy their votes.

It has long been noted that the general composition resembles that of Leonardo da Vinci's *Last Supper*, which, on the basis of Christ's prediction of his betrayal by Judas, can be regarded as a definitive image of broken loyalties. It is not Christ who is being betrayed here but the tradition of British liberty.[24]

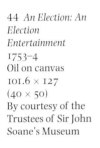

44 *An Election: An Election Entertainment*
1753–4
Oil on canvas
101.6 × 127
(40 × 50)
By courtesy of the Trustees of Sir John Soane's Museum

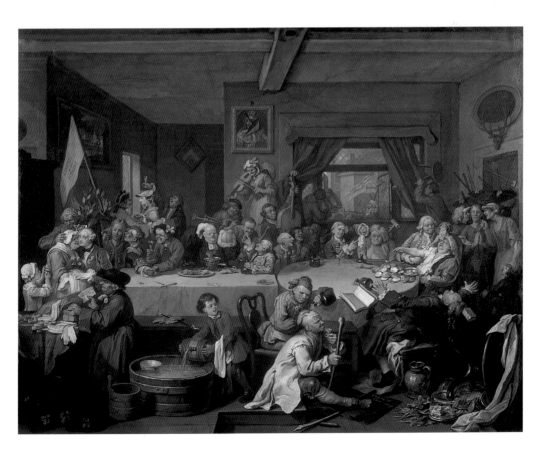

On the wall behind is a slashed portrait of William III who had been installed on the British throne by parliament to ensure the maintenance of constitutional liberties and Protestant rule. One commentator observed that the scene shows the desecration of the memory of 'King William who vainly imagined that his subjects loved liberty better than party'.[25] It is significant that it is the Whig party, that most associated with the slogan of parliamentary liberty, that is in the foreground of the desecration. Through the window, however, the Tory celebrations can be observed in which similar slogans of liberty are being bandied about. It is clear that words such as 'liberty' and 'loyalty' have become no more than a matter for banners, whereas the real concern of the populace and their leaders is with private interest and indulging the moral licence consistent with such occasions.

The mid-1750s, when Hogarth embarked upon his *Election* series, was a time when the behaviour of 'the mob' was of great concern to polite society. The *Gray's Inn Journal*, an essay magazine produced in 1753 and 1754, devoted a whole issue to this subject. Humorous as the tone of the article was, it reflected a genuine fear of a populace who could not be controlled and who threatened to subvert the whole political order. The author's observation that Britain was being turned into a 'mobocracy' nourished by vulgar slogans constituted a truly serious piece of humour:

> They have many wise maxims by which they govern themselves; such as 'no wooden shoes', 'liberty, property and no excise' ... 'let every man toast his own cheese' & co. Such providential axioms, founded on the soberest sense, must undoubtedly render their administration both wise and prosperous. It does not appear that that they have made any progress in the modern Art of War; on the contrary, there is reason to suppose that they hold it in contempt; as it is certain that on many occasions, when our mixed form of government has attempted to oppose them by sending the soldiery against them, they have always laughed at the military and repelled them from the assault without their daring to fire. Their military discipline seems derived from the Romans; they know no use of cannon, firearms & co. but proceed to battle with sticks, bludgeons, setting up loud shouts, somewhat like the war-hoop of the Indians, and hurling stones, brickbats, bottles and glasses & co. with tremendous force on the adverse party.[26]

Hogarth seems to have shared this sense of the fear of mob control. In the first and last images of the *Election* series he illustrates this point with the use of a musical analogy (fig.45). Both scenes include the figures of ragged fiddle players who provide musical accompaniment for the din of the crowd. These figures constitute a joke on the theme of harmony. It was often claimed that the British political constitution presented a harmonious blend between the power interests of people, parliament, aristocracy and monarchy. Here it would appear that it is the rough music of the lowest sort of people that dominates the constitution. This music, of course, has no trace of harmony.

This reference to musical harmony reflects Hogarth's enduring concern with the concept of balance, a concept obviously much akin to the polite

ideal of moderation. In the final election scene, *Chairing the Member* (fig.45), Hogarth returns to a favourite form of imagery, the impending collapse. An accidental cudgel blow from a man who is meant to be defending the winning candidate knocks out one of those who is bearing his chair. Faced with mocking images of the vanity of human ambition, a grinning skull and sun dial, the enormously fat politician topples backwards towards a waiting stream that serves as a parish gutter in which a stray piglet swims. Hogarth's point is clear: those who are raised up by swine and the social dregs are destined to fall to their level. Sent tumbling by a chance blow, this figure restates Hogarth's preoccupation with the disastrous consequences of a political state abandoning itself to the chaotic forces of fortune.

The second image of the series also features a commentary on the failings of balance, or the disinterested middle course, in the party political system (fig.46). In the foreground we see an inn, the Royal Oak, at which votes are being bought. The name of the inn, which suggests the famous or notorious loyalty of the Tory party to the Stuart cause, defines it as a symbol of the conduct of that party. In the background a further inn, which declares by its sign a loyalty to the Hanoverian Succession, symbolises the affairs of the rival Whig party. This inn is the scene of a popular riot, illustrating the tendency of Whig values of liberty to decline into mere chaos. Beyond this a small unfrequented inn represents the territory of independency and patriotism. The

45 *An Election: Chairing the Member* 1753–4
Oil on canvas
101.6 × 127
(40 × 50)
By courtesy of the Trustees of Sir John Soane's Museum

deserted road that separates the inns adds to the sense that the middle way of balance and moderation has been abandoned for the sake of venality.

Hogarth completes his point that patriotism is being betrayed with the image of a ship's figurehead outside the Royal Oak. This, as some contemporaries would have remembered, referred to the purchase in 1749 of the figurehead of Admiral Anson's ship, the *Centurion*, by the Duke of Richmond, who set it up outside a pub at Goodwood. This figurehead, which took the form of a British lion consuming the French *fleur-de-lis*, had spearheaded Anson's fleet on its voyage around the world. The voyage, which had been partly financed by the privateering of foreign vessels, had been taken as the classic expression of the British spirit of brave adventure. A verse celebrating Richmond's purchase was published in the *London Magazine* of 1749:

Stay, traveller, a while and view
One who has travelled more than you;
Quite around the world, thro' each degree,
Torrid and frigid zones have passed,
And safe ashore arrived at last,
In ease and dignity appear,
He – in the House of Lords – I here.[27]

Assuming that Hogarth was aware of this verse, it seems reasonable to posit that he was thinking in terms of creating an image on the theme of rewards and exchanges. The verse turned on the idea of contrasting rewards: Anson had received his reward by being made a peer; the figurehead was somewhat less fortunate achieving only a last resting place in a humble setting. Hogarth was quick to add to the humour by presenting this piece of popular patriotic sculpture as a seat around which a highly disreputable system of rewards operates. On the figurehead there sits a female doorkeeper who accepts money from a soldier for access to the rooms above, where well-dressed whores reside, an obvious analogy to the similarity between the buying and selling of votes and prostitution. There could not have been a more forceful image of a libertine state.

This scene of the *Election* series centres on Hogarth's final image of personal choice. A crafty-looking fellow accepts money from the agents of both parties, trading on the strength that he is in a position to choose between them. This was one of three occasions when Hogarth converted to humorous effect the most famous 'high art' icon of the idea of choice, Lord Shaftesbury's design for *The Choice of Hercules*.[28] Shaftesbury, the most notable philosophic proponent of the idea that painting should serve the purpose of the moral education of the citizen, held that the ideal subject for history painting was this moment of choice. This moment was when Hercules, given the choice between the hard course of virtue and the soft pleasures of life, elects for a life of virtue. This idea was symbolised by placing the figure of Hercules between two rival female figures emblematic of these values.

In the *Election* series Hogarth affectionately parodies Shaftesbury's idea. His figure is presented with a choice between two vices and enriches himself by taking no decision. Two decades earlier, in the second scene of the *Rake's*

Progress, he had subverted Shaftesbury in a similar manner by showing a central figure of Rakewell choosing between an array of competing vices. The image was also used in *The March to Finchley*, which features at its centre a British soldier caught between the attentions of an English maid whom he has made pregnant and a chiding Jacobite woman who has some prior claim on his affections. This group obviously functions to symbolise the nation's choice between a fertile and barren future.

Hogarth's concern with the imagery of choice was consistent with his preoccupation with providence and fortune. To accept that accidents of birth and circumstance dictated the affairs of men was to negate men's responsibility for their conduct. Only by preserving the idea that individual lives were dictated by choices, albeit choices made between vices, could Hogarth support the general philosophic conviction that men got their deserts. Upon this conviction rested the more fundamental faith in the providential order and the goodness of God. Hogarth's world was an Eden made base by man and not, as his opponents assumed, a base world. For all that he concentrated on the realm of vice, misery and the process of degeneration, he deserves to be remembered for communicating to civilisation the most positive vision of the human condition.

46 *An Election:*
Canvassing for Votes
1753–4
Oil on canvas
101.6 × 127
(40 × 50)
By courtesy of the
Trustees of Sir John
Soane's Museum

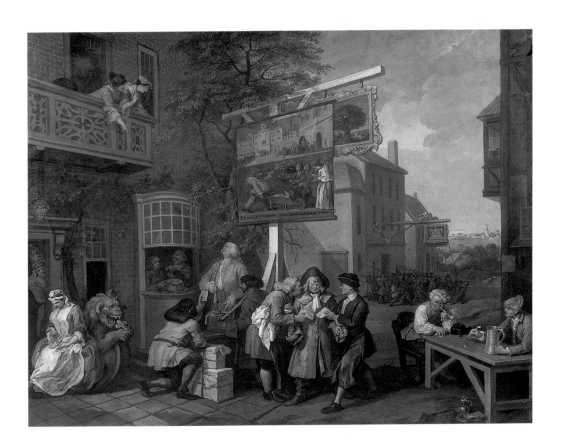

5

HOGARTH'S SYMPATHY FOR, AND AFFINITY WITH, THE 'NOBODIES' OF SOCIETY

Like many self-made men of his period, Hogarth was much taken with the idea that wealth had its responsibilities and that there was something immoral about climbing the social ladder without looking back charitably at the world one had left behind. For those who believed in the values of self-reliance, however, the whole notion of charity had its pitfalls. In the mid-eighteenth century, as in today's climate of state welfare, there were many who considered that giving to the poor without discretion compounded a culture of indolence. For persons with such concerns the challenge was to find, or invent, charities that plainly served the interests of the 'deserving' or those who had no part to play in their disadvantage. For Hogarth an ideal institution was the Foundling Hospital, a charity newly established by Thomas Coram, a retired sea captain. He was one of the founding governors of the Hospital in 1739 (fig.47).[1]

There were those who regarded the institutional care of foundlings as an encouragement to women to have incautious sexual relationships. If Hogarth had such qualms they are not recorded. Rather, the charity seems to have appealed to him on the basis of the manifest innocence of its charges. It is no coincidence, given his concern with self-improvement, that he became closely concerned with Coram's Hospital. Of all London charities, it was most patently concerned with realising the national ideal of a society in which 'free born' citizens were given a fair chance of self-improvement. The main factor militating against the formation of such a society was that many citizens were faced with such manifest disadvantage at birth that they had no realistic prospect of turning themselves into useful citizens. Hogarth, like the self-made mercantile founder of the charity, entertained the belief that giving a proper start to foundlings was not only an immediate kindness to the children concerned but also a boon to society at large, which would be rewarded with a host of useful citizens.

A promotional image that Hogarth designed to encourage subscriptions to the charity made this aspiration clear (fig.48). He awards all the foundlings with some attribute of a useful trade or profession, indicating that it was the intention of the Hospital to give all foundlings the basic opportunity to set about their own improvement. The official line of the Hospital's promotional literature was that the foundlings' prospects were limited: girls were encouraged to go into service and boys into mundane trades and the lower orders of seafaring.[2] Hogarth may have had grander ideas. This may be indicated by his

47 *Captain Thomas Coram* 1740
Oil on canvas
239 × 147.5
(94 × 58)
Coram Foundation, London, UK

The Royal Charter

Painted and given by W.m Hogarth. 1740

48 La Cave after
William Hogarth
The Foundlings 1739
Engraving
36.2 × 21.8
(14¼ × 8½)
The British Museum

49 *Moses brought
before Pharaoh's
Daughter* 1746
Oil on canvas
172.7 × 208
(68 × 81⅞)
Coram Foundation,
London, UK

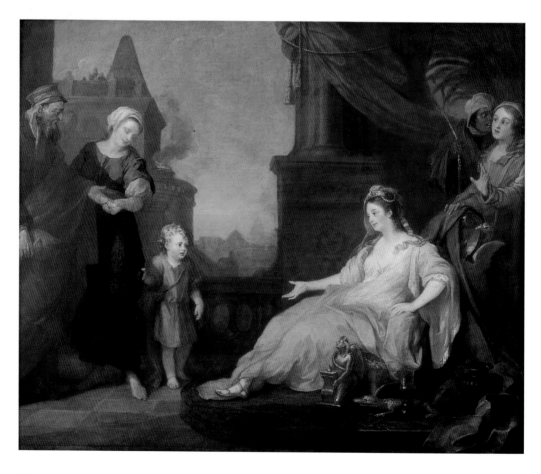

choice of subject for a painting which he made to hang alongside that of the work of other artists in the Court Room of the charity. In presenting his fine image of *The Infant Moses brought before Pharaoh's Daughter* (fig.49), Hogarth may well have been hoping to remind all future governors, as they sat in convocation, that one should not underestimate the potential of any foundling with whose protection one was charged. With Moses as a model what limits might be placed on the aspirations of the foundling child?

In the scheme for the Foundling Hospital Hogarth found a means of realising the ideal of a society that turned upon the principle of liberty. This idea was enshrined in the coat of arms that Hogarth designed for the society (fig.50). The figure of many-breasted Artemis/Nature, probably signifying the naturalness of human compassion and beneficence, is presented alongside that of Britannia who bears a cap of Liberty. Hogarth's point was, surely, that only in a national society founded upon liberty could there be a full realisation of man's natural tendency to show sympathy for the innocent. As the founders of the Foundling Hospital were fully aware, the first scheme of this type, the *Hôpital des Enfants Trouvés* (established 1670), had been instigated by the French under conditions of royal patronage. A print by Hogarth's acquaintances Charles Grignion and Samuel Wale showing a perspective view of Coram's Hospital with emblematic figures made reference to this point of history.[3] It shows a group of spiteful, fashionable Frenchmen mocking the charity. Near them a number of foundlings dance freely around a statue emblematic of Venus and loving abundance. It was, presumably, considered that Frenchmen, accustomed to authority and arbitrary power, were unlikely to understand the free and happy environment of an English charity.

The Foundling Hospital, however, was designed not only to contrast with continental institutional charities but also to conform to ideals of liberal governance new to England. This hospital was, along with contemporary London foundations such as St George's Hospital at Hyde Park Corner and St Luke's

50 *The arms of the Foundling Hospital*
1747
Engraving
19.5 × 20.3
(7⅜ ×8)
The British Museum

Hospital for the Insane, a manifestation of the charitable instincts of the socially aspirant 'middling sort'. At the turn of the eighteenth century most London charities were run by confederacies of prominent City luminaries and aristocratic patrons.[4]

Though founded with the support of aristocratic patronage, the Foundling Hospital owed its central impetus to the co-operation of numerous industrious commercial folk. Those artists who helped to promote the charity by embellishing its Court Room with splendid works of art were simply providing an immediately visible example of the philanthropic aspirations of such sectors of society. The claim of the industrious 'middling sort' to the helm of a new sort of charitable society was, at least partially, based on the notion that, having risen from lowly stations in life, they were best placed to recognise and service the needs of the deserving poor. These industrious folk felt that charities did not simply reflect the need of powerful men to govern the fates of the poor and disadvantaged. Men such as Coram and Hogarth saw the possibility of a charitable society that fundamentally promoted the ideal of a free, as opposed to a formal and authoritarian, philanthropic society.

The idea that those of 'plain' commercial politeness, untainted by fashionable manners and haughty social posturing, were best qualified to set the tone of a free and philanthropic society was central to Hogarth's psyche. He conformed to a vision of politeness that stressed that the formal swagger of authority and status was not just unnecessary but highly counter-productive. It is important to note that two of his graphic tales of degeneration begin with displays of family heraldry. The Rake receives his inheritance in a room decked out with heraldic escutcheons designed for his father's funeral (fig.51).

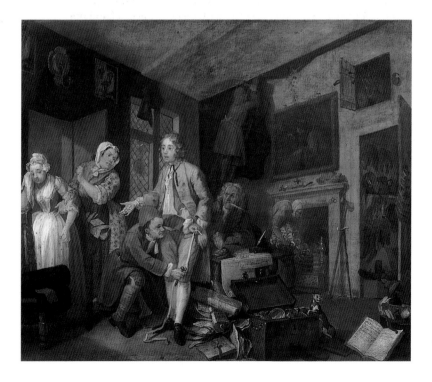

51 *A Rake's Progress: The Heir* 1733–5
Oil on canvas
62.2 × 74.9
(24½ × 29½)
By courtesy of the Trustees of Sir John Soane's Museum

Hogarth's inference is that a miserly father has preserved the family as a heraldic entity but has paid no attention to the proper education of his son to encourage him to embrace genuine domestic virtues. The *Marriage A-la-Mode* begins with the proud father of the groom holding up a parchment scroll revealing his pedigree, which has become a mere formal symbol of a nobility that has no substance either in terms of finance or conduct (fig.25). Posturing before a curtained baldachin, the peer embodies the idea of the man who requires material props to make him look great.

When subverting the pomp of heraldry, Hogarth was subscribing to the arguments of those of his contemporaries who argued the superiority of 'bred' over 'born' gentility: the former being inculcated by education and grooming, the latter being inherited. This idea had an obvious appeal to low-born commercial folk and those taken with ideals of self-improvement. It is not surprising to find that conduct manuals placed great emphasis on the idea that 'nobility' was something to be cultivated rather than inherited. A fine passage on the subject of 'pride' in *The Gentleman's Library* provides as good a context as can be found for Hogarth's satire on the gouty peer and his dissolute son in the *Marriage A-la-Mode* series:

> Hereditary nobility seems no just ground for high opinion, because it is borrowed. Those great actions which we have no share in can like property be part of our commendation, especially if we want abilities to imitate them. He that depends wholly on the worth of others ought to consider that he has but the honour of an image and is worshipped not for his own sake but upon account of what he represents. It is a sign a man is very poor that he has nothing of his own to appear in, but is forced to patch up his figure with relics of the dead and rifle tombstones and monuments for his reputation. It is a real advantage, or what should exalt us to high-flown thoughts, that we stand at the bottom of a long parchment pedigree, and are some yards removed from the first escutcheon?[5]

It is important to observe that this sort of attack on the concept of hereditary nobility was not an attack on aristocracy *per se*. According to *The Gentleman's Library* and most other commentaries on the concept of 'nobility', the 'born' gentleman was not excluded from the polite realm, he was merely required to demonstrate that he also had 'breeding'. However, there is no mistaking the fact that this ideological position to some extent required men of born gentility to dance to the social tune of their formal inferiors. These standards of 'breeding' were largely established by the literary 'middling sort'. The sight of a low-born individual such as Hogarth satirising the pretensions of the 'born' society is just one form of evidence of the degree to which the moral authority of eighteenth-century English metropolitan society was slipping into the hands of the industrious commercial sector.

Part of the claim of this sector to moral authority was a sense that their acquired politeness, as opposed to the haughty posturing of the fashionable and august, had a natural hold on the respect of the lower orders. Hogarth's fine painting of the heads of his servants (fig.52), which he invested with as

much attention to character as his aristocratic portraits, suggests the humane household governance of a man who had not forgotten that it was only money that divided the world above from the world below stairs. If we wish to enquire as to where Hogarth acquired his own sense of a humane household we may look no further than his enduring friendship with the Hoadly family.

Hogarth knew, and painted the portraits of, all the principal male members of the Hoadly family: Bishop Benjamin (fig.53); his elder son and namesake, who was a physician and playwright; and his younger son John, a genteel cleric who shared his brother's bent for writing. Bishop Hoadly, one of the most controversial ecclesiastical figures of his age, was a radical opponent of any vestige of mystical theology that remained within the Church of England and the 'enthusiastic' piety of some sections of English Protestantism. Although far from a paragon of selfless charity, the bishop was at the centre of the formation of the sort of 'low church' theology of good works that underscores Hogarth's moral agenda. His son John expressed this religious stance by erecting a fine monument in memory of his loyal housekeeper, which featured a worthy mongrel dog guarding the keys of the household (fig.54). This monument was erected in the parish church of Old Alresford, close to the rectory where Hogarth spent a holiday in 1746.[6] Some years before erecting the mon-

52 *Heads of Six of Hogarth's Servants*
1750–5
Oil on canvas
63 × 75.5
(24¾ × 29¾)
Tate

53 *Benjamin Hoadly, Bishop of Winchester* 1741
Oil on canvas 127.3 × 101.5 (50⅛ × 40) Tate

ument, John had drafted a play for David Garrick with the title *The Housekeeper*, which satirised life below stairs.[7] The monument was probably intended to convey his sincere admiration for the very figure he had fondly satirised. Like Hogarth, he accredits his servant with the same respect accorded to a person of social consequence; he had the monument made in London at one of the finest sculpture shops. Here also was a man who seemed willing to make visible the role that the ordinary working person had to play within the moral realm of society.

Hogarth has the distinction of being the first artist in English history to produce images that suggest that ordinary working people have a virtue, a humanity, and even a beauty, to rival persons in high society. I concur with Ronald Paulson, a modern authority on Hogarth, in regarding the artist's famous painting of *The Shrimp Girl* as an attempt to show that beauty could be found in the commonest quarters (fig.55). On occasions Hogarth even hinted that fashionable society might have something to learn from the plain, unaffected ways of those to whom it looked for mundane services, and this was not just a personal idiosyncrasy. He catered for a polite public that was, in the 1740s and 50s, finding numerous reasons to look favourably upon the labouring world. It should be remembered that throughout the 1740s Britain was engaged in less than successful continental and maritime wars. These were concluded by a peace treaty in 1748 which even its most ardent supporters could not turn into a triumph. Moral critics, most notably the robust John Brown, author of a famous *Estimate* of the times, were quick to blame these martial failures on the luxury and 'effeminacy' of youths from the polite classes and the poor example they gave to their more humble countrymen.[8] In these circumstances it was natural to look upon those quarters of society who were beyond the reach of enervating luxuries as the true stock of the nation.

While the lower orders were beyond the dread grasp of luxury, it was plain that there were ways in which they could emulate the degenerative habits of people of higher estate. Hogarth's famous comparative prints of Gin Lane and Beer Street (figs.14, 15) can be interpreted as attempts to promote a culture in

54 Attributed to
H. Cheere
*Monument to Mrs
Anne Davenport*
Marble
D. Sherborn

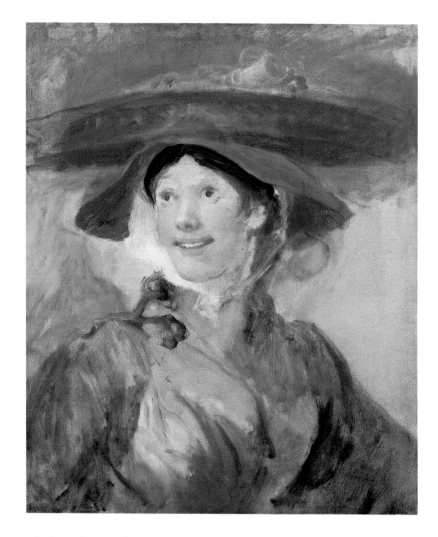

55 *The Shrimp Girl*
Oil on canvas
63.5 × 50.8
(25 × 20)
National Gallery,
London

which the lower orders would not pursue the means of dissipation that were within reach of their pocket. The hideous Mother Gin who presides over the decay of London was placed before the public as an emblem of the vices that attend and bring about poverty. The citizens of Beer Street, who are uniformly stout and jovial, represent the core of the body politic in a state of health and comfort suitable to its common function. On the health of this plump body, Hogarth suggests, rests the fate of commerce and national prosperity.

Hogarth seems, however, to have added to his image of Beer Street some cautionary details, perhaps intended to temper public sympathy for the lower orders. He makes it plain that a bluff labouring society should not be confounded with a civilisation, in so far as the latter concept implied the capability to support refinements such as the polite arts. The ragged state of the sign painter is sufficient to indicate that he believed that it would take more than stolid good humour to keep artists employed. We even see a basket labelled for delivery to a trunkmaker in which are stacked erudite antiquarian tomes and august works of art theory. These, one presumes, are ready to be cut up to

make lining paper for boxes. It is questionable whether Hogarth believed that it was a laudable facet of a simple society that pompous works such as Turnbull's *Treatise on Ancient Painting* would be treated in this manner. Whatever Hogarth's precise meaning, it is clear that he wished to point out the strong disparity between a world of simple pleasures and cultural sophistication.

While Hogarth was capable of valuing the common man and satirising the aristocracy, it would be an exaggeration to argue, as some leftist historians have done, that Hogarth is an essentially subversive or 'anti-aristocratic' figure.[9] The notion that Hogarth was a muscular proponent of a sort of 'bourgeois revolution' that challenged the moral and political authority of the 'born' orders is seductive but ultimately simplistic. It must be more accurate to view Hogarth as representative of the socially aspirant 'middling sort' who directed the morality of his art to preserving the structure of a formal social order. Like his friend Henry Fielding, Hogarth seems to have been committed to a vision of a world in which a clear sense of the formal stations of life was preserved. In this world the 'blood' aristocracy was obliged to perpetuate itself and its class by abstaining from destructive luxuries and follies. At the base of the social pyramid it was essential to preserve a virtuous and industrious mass. In the centre, which Hogarth assumed to be his point of vision, the artist dreamed of an 'inventive' and commercial core of people whose virtue was encouraged by a sense of liberty to aspire to the level their merits deserved. It is important to remember that people with social aspirations in the mid-eighteenth century, such as Hogarth, had no interest in completely subverting the traditional order of society. The social climber needed a society to climb. If the ranks of society were completely subverted, there would be nothing substantial on which to concentrate one's aspirations.

Hogarth's *oeuvre* may be surveyed in vain for an image that could be defined satisfactorily as 'anti-aristocratic'. While it is possible, for instance, to regard the *Marriage A-la-Mode* series as an attack on the traditional obligations of respect accorded to the blood nobility, I believe this would be a simplistic interpretation. Hogarth's point was, surely, to lament the degeneracy of a fashionable world in which it was necessary for a peer to marry his son outside his class in order to patch up his strained financial circumstances. Hogarth seems to be attacking 'mode' as an enemy of tradition, not to be attacking tradition itself. The evils of society are regarded as the modish consumer temptations, from a grand London house to foreign paintings, that cause old landed families to die out. By naming the peer's son 'Viscount Squanderfield' Hogarth betrays a sympathy for the idea that the old landed aristocracy was best employed in preserving its traditional landed hereditaments.

Sympathies of this kind are noticeable elsewhere in Hogarth's work. We have already seen how his image of *The Cockpit* (fig. 36) can be interpreted as a critique of the tendency of gambling to undermine and blur the distinctions of class. Similar points were made in the first scene of the *Election* series (fig. 44). Here we are treated to the disturbing sight of the aristocratic candidate and his family 'pressing the flesh' of ragged voters. This is presented as a further sign that the world of this election is topsy-turvy, the aristocracy pandering to the lowly electorate rather than showing the dignity of leaders.

Hogarth could be as scathing about the great person's attempt to vulgarise himself as the vulgar person's attempt at self-aggrandisement. This much is evident from his *Harlot's Progress* (figs.1–6). Among 'Molly Hackabout's' character deficiencies is her aspiration to live beyond her means and above her class. Her error is to attempt to climb the social ladder by immoral means. The second scene of the *Progress* shows her playing the role of a lady of means, inhabiting an urban world of elegant tea parties and fashionable masquerades far distant from her plain Yorkshire roots.

Hackabout's funeral constitutes her final act of social pretentiousness (fig.6). She has obviously saved her last pennies to afford a pathetic downmarket imitation of a heraldic funeral. An undertaker has been paid to provide escutcheons and mourning drapes. Much as she has lived a life of pretence, those who mourn her seem incapable of anything other than fake grief. Hogarth's presentation of her mourners' crocodile tears needs to be understood against the context of a polite culture that tended to distrust 'enthusiastic' display of emotion on such occasions. An example of typical contemporary opinion may be found in a conduct manual's advice on how to behave at times of mourning:

> Grief and weeping are indeed frequent companions but, I believe,
> never in the highest excess, for it is well known that the heart attended
> with grief stops all passages for lamentation and tears. Thereby, the
> sorrow which appears so easily in the eyes, cannot have pierced deeply
> the heart. And as laughter does not proceed from profound joy, no
> more does weeping from profound sorrow, but, on the contrary, true
> affliction labours to be invisible; it is a stranger to ceremony and bears
> in its own nature a dignity much above the little circumstances which
> are affected under the notion of decency.[10]

This passage alerts us to the root of Hogarth's distrust of some manifestations of social climbing: the tendency of the earnest doctrine of self-improvement to degenerate into a mere desire to cultivate an appearance of gentility. Such social theatre was thought to undermine the ideal of polite society and to constitute an insincere show of 'decency' or superficially pleasing behaviour, which disguised vicious and ignoble motivations.

Hogarth's *oeuvre* reflects at numerous junctures one of the defining social skills of eighteenth-century politeness: to act in accordance with rank and yet not stand haughtily on class prerogatives. Hogarth moved in a society in which preserving the distinctions of rank was deemed essential to decorous behaviour; whereas placing too heavy an emphasis on these distinctions was considered to destroy the ease and affability necessary to agreeable company. It is a sign of Hogarth's 'politeness' that his work in the field of portraiture consistently strives to communicate his ease in the company of his formal social superiors. His anxiety to stress that he was comfortable in the society of the great led Hogarth to specialise in 'conversation pieces' that reflect a humorous familiarity with the intimate relationships of his subjects.

A fine instance of this is the portrait of the Strode family of Ponsborne Hall (fig.56). Here Hogarth shows a domestic group taking tea, observing both

appropriate hierarchy and familiarity. William Strode, MP, the eldest son and head of the family, signifies his position in the family most elegantly by taking charge of the tea ceremony. He touches the hand of a family friend, Dr Arthur Smyth, in order to offer him a freshly poured cup. Appropriately for a modern polite family that did not make a haughty show of rank, the butler is not just included but granted a central position. To the edge of the canvas stands William's younger brother, Colonel Samuel Strode, who seems, from the cane in his hand, either to be about to go for a walk or to have just returned. The Colonel's pug dog appears to present a threat to the meal of his brother's spaniel. The spaniel growls and the Colonel employs his cane to avert a possible fight. The point of this joke is not clear. Perhaps Hogarth was straying delicately into the issue of fraternal rivalries.

Whatever the precise meaning of Hogarth's imagery in this painting, it was probably intended to distinguish his group portraiture from the sort of starched formality that marked the works of competitors such as Devis and

56 *The Strode Family*
1738
Oil on canvas
87 × 91.5
(34¼ × 36)
Tate

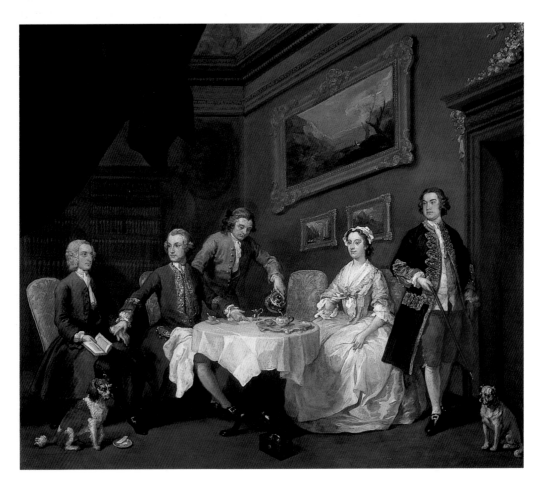

Philips. By including such humorous touches, which characterise his group portraits, he probably intended to elevate this form of art. Hogarth utilised his wit and talent for observing human relationships in a type of art that he criticised for demanding a mere facility for recording outward appearances. That he insisted on turning portraiture into a commentary on intimate relationships reflects his general anxiety, as recorded in his biographical anecdotes, not to demean himself by taking on portrait commissions. He appears to have shunned the sort of portraiture that merely served the 'vanity' of the sitters in order to distance himself from the sort of artist who fawned and scrapped for preferment. In exchange for their money Hogarth ensured that his patrons not only received an imitation of their faces and garments but also a commentary on their identities.

It should not be imagined that Hogarth was the only artist working in England at this time to experiment with new levels of informality in group portraiture. The French/German immigrant, Philip Mercier (1689–1760), seems to have been welcomed into the household of some of his patrons, in particular the Samwell family of Northamptonshire, and required to make images of informal and humorous moments in their lives. Hogarth's friend, Francis Hayman (1708–76), also specialised in relaxed, affable groupings. Hayman's intriguing portrait of himself at ease in the company of a group of gentlemen (1745–8) – a group probably including his greatest patron, Grosvenor Bedford – tells us much about the desire of some artists of this time to be recognised as partakers in, as opposed to mere recorders of, genteel society.[11] This work can be profitably compared to Hogarth's *Lord George Graham in his Cabin* (fig.57), one of the artist's greatest works.

In this painting Hogarth satirises the convention of artists placing their own portraits in the company of the great. Rather than pompously introduc-

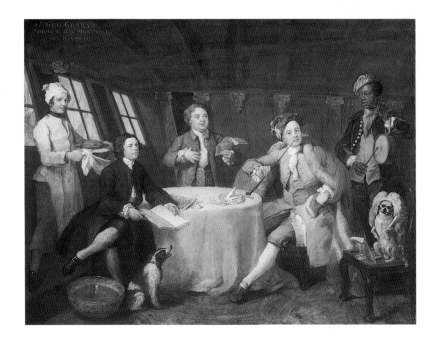

57 *Lord George Graham in his Cabin*
1745
Oil on canvas
71.1 × 88.9
(28 × 35)
National Maritime Museum

ing an image of himself into 'high society', Hogarth substitutes the figure of his pug dog and personal mascot. To parody the pomposity of the convention he poses the dog in a rather over-consequential wig pontificating with a scroll. Behind the pug a black cabin boy bangs a drum, setting up a dreadful din that functions as a reflection on the quality of the white folk's drunken music making. That Hogarth jocularly presents himself as part of an outer ring of menials, in the same sphere as a black boy and an idiotic cabin boy who pours gravy down a guest's neck, perhaps reflects his awareness that these margins were thought appropriate to artists who could be regarded as no better than servants. By presenting himself as a dog in a wig, and the most ridiculous element of a shambolic convivial group, Hogarth may well have been parodying the efforts of other artists to signal their inclusion in polite and respectable society. It is well to remember when looking at this painting that it is a record of life in the highest social spheres. Lord George Graham was the son of the Duke of Montrose and the cabin, with its row of ionic pilasters, is the finest of naval interiors. Hogarth was showing that he was not just admitted to such society but sufficiently comfortable within it to make a joke at the expense of polite society and artists' attempts to be seen to be part of it.

Hogarth's device of presenting himself in the emblematic form of his pug dog was, as we have seen, a sophisticated comment upon his common, mongrel origins. A man of small physical stature, Hogarth seems to have enjoyed a joke at the expense of his anxieties to triumph over his own apparent insignificance. The firmest evidence that we have of this self-image emerges from a satirical manuscript book compiled by Hogarth and a group of friends to celebrate an impromptu trip to the suburban countryside in the mid-1730s. The artist and his friends appear to have decided after a few drinks that it would be fun to lampoon the whole pompous practice of learned antiquarian travels as promoted by figures such as William Stukeley. It was decided that a book should form the very antidote to such a compilation of serious observations. It was crammed with vulgar stories, commonplace observations and illustrations of banal scenes. At the core of their humour was the idea that they were a group of 'Nobodies' satirising the pretensions of those learned persons who presumed that, because they were 'Somebodies', the world would be interested to read their tedious reflections. Hogarth contributed to the book archetypal portraits of 'Nobody' (fig.58) and 'Somebody'.

When considering the general timbre of Hogarth's creative and social identity, it is important to remember his self-image as a 'Nobody'. The assumption of this identity marks his desire to express the essential values of 'polite' self-improvement: that one should remember, as one advanced through society, the common dust from which one arose. This remembrance acted as an insurance against the indecorous practice of pretending to be someone more circumstantial than one's origins suggested. Hogarth's propensity to communicate some sense of his own common humanity through his art, while seeking to define himself as someone of uncommon abilities, is one of the central dynamics of his creative identity.

As his involvement with the Foundling Hospital and the invention of his paragon Goodchild testify, Hogarth appears to have been beguiled by visions of

58 *Mr Nobody* 1732
Brown ink over
pencil with
watercolour
27.9 × 38.1 (11 × 15)
The British Museum

man's capacity to overcome the dirt, danger and calamity that could accom-
pany lowly origins. That this was so probably reflects his remembrance, in less
idealistic moments, that the world of the gutter and that of polite domesticity
were not in practice easy to separate. There is, indeed, no artist of the eigh-
teenth century who more completely explores the complex hinterlands in
which 'high' and 'low' culture co-existed, the dirt of one invariably rubbing off
on the other.

It is one of the great ironies of Hogarth's career that a studious desire to
articulate and reinforce distinctions between the polite public realm and baser
social elements stimulated, in practice, an impression that he endorsed the
intermingling of such elements of society. In reality, the commercial success
of much of Hogarth's art was dependent on the desire of those in high life to
puncture further the tattered barriers that divided them from the enjoyable
vices of ordinary labouring folk. At least part of the appeal of his scenes of low
life was that they provided windows of riotous escape for those members of
polite society who were fated by their prosperity to inhabit a world of codified
and restrictive social behaviour.

As his fame grew, Hogarth heard with increasing frequency the charge
that he was a 'burlesque' humorist who profited from the low pleasures that
his observers received from the voyeuristic observance of vice. His career
being built on the construction of dirty and disorganised worlds, he could not
avoid the tendency of some of his public to invest him with the low character-
istics of his own inventions. Attempts in later life to produce art and theory of
conspicuously 'high' pretensions were greeted with wide-scale derision.
While his enemies mocked him as a vulgar little fellow who had overstepped
himself, even some of his supporters urged him to stay with the 'low' genres
in which he excelled.

His talent for exposing the degeneracy at the core of national life laid him
open to particular criticism when, through the publication of his *Analysis of
Beauty*, he attempted to set himself up as an authority on the nature of beau-
ty. Opponents in the painting profession, in particular Paul Sandby, found
their opportunity to mock him as the master of deformity whose tubby
physique mirrored his mind's tendency towards the burlesque. He was, some-

what inevitably, lampooned for producing 'hog-art' in practice and waxing lyrical about beauty in theory.[12] Hogarth was thus lampooned not just for his insistence on the common denominators of humanity but for attempting to reduce humanity to the level of beasts by showing men in their undignified moments. We know from the testimony of his own biographical anecdotes that these public attacks hurt him deeply. At the very point in his career that Hogarth began through his art to act as a genteel commentator on the low proclivities of the mob he was dragged into sordid public squabbles by those who questioned his politeness.

At the close of his career Hogarth appears to have reached some final philosophical acceptance of the idea that there was something about him that would always be common. The final print that was published in his lifetime, entitled *Tailpiece: The Bathos* (fig.59), can be interpreted as a subtle confession that he excelled at being a common mortal. This image focuses on an assortment of commonplace *memento mori*. Its title, *The Bathos*, a word implying the reduction from the sublime to the ridiculous, hints at Hogarth's awareness that time will bring an end to all his sublime ambitions.

Part of the sophistication of the image is that it is based on the then famous engraved frontispiece to Pope's *Essay on Man*. This shows the poet accompanied by Time among classical ruins, reflecting upon the folly of all human endeavour. Instead of these august ruins Hogarth employs a pile of English symbols of death of the sort that attended the life of a common man who needed apocalyptic religion to frighten him into faith: an ordinary gravestone with skull and cross-bones is accompanied by an absurdly apocalyptic sign for the World's End Tavern, and a broken parish bell. This is Hogarth's *Essay on Man*, humble and English rather than grand and cosmopolitan. Hogarth finally wished to be remembered for a wisdom that was suited to a commonplace world.

59 *Tailpiece: The Bathos* 1764
Etching and engraving
26 × 32.4
(10¼ × 12¾)
The British Museum

Notes

Introduction

1 The idea that Hogarth was a writer who made images emerged first during his lifetime. The author of an article in the *Gray's Inn Journal* (1753–4, vol.II, no.67) stated, for instance, that 'he may be said to have been the first who wrote comedy with his pencil'.

2 Paulson, R., *Hogarth: His Life, Art and Times*, New Haven and London 1971, and Uglow, J., *Hogarth*, London 1997. The best shorter biography of Hogarth is David Bindman's *Hogarth*, London 1980.

3 Those requiring an in-depth analysis of this series would do best to turn to Simon, R. and Woodward, C., eds., *A Rake's Progress: From Hogarth to Hockney*, exh. cat. Soane Museum 1997, printed on behalf of *Apollo Magazine*.

Chapter One: The Freedom of the Times

1 Titles that typify this genre are *Rococo: Art and Design in Hogarth's England*, exh. cat. Victoria and Albert Museum, London 1984, and Jarrett, D., *England in the Age of Hogarth*, London 1974.

2 Hogarth's increasing awareness of his role as a critic of his own times, or the fashions that defined them, is reflected in the titles of late works such as *The Times* of 1762 and *Taste in the High Life* and *Marriage A-la-Mode* of the mid-1740s.

3 In using this phrase, I combine words from the titles of two of the best, and most frequently read, accounts of Britain in this period: Dickinson, H.T., *Liberty and Property: Political Ideology in Eighteenth Century Britain*, London 1977, and Langford, P., *A Polite and Commercial People*, London 1989.

4 I use the word 'rediscovery' in order to communicate the idea that many advocates of national liberties in this period believed they were reviving ancient national traditions deriving from Saxon times.

5 Those wishing to read further on the effect of legislation on the growth of the press would be best to refer to Black, J., *The English Press in the Eighteenth Century*, Beckenham 1987, and Harris, M.R., *London Newspapers in the Age of Walpole*, London 1987.

6 Those wishing to comprehend the concept of slavery to 'taste' as understood in this period can do no better than consult a copy of James Bramston's satirical play, *The Man of Taste*, 1732.

7 The best study of changing attitudes to pleasure is Porter, R. and Mulvey Roberts, M., *Pleasure in the Eighteenth Century*, London 1996.

8 A good introduction to the shift of culture away from the decadence of the Caroline court appears in John Brewer's *The Pleasures of the Imagination*, London 1997, ch.1, 'Changing Places: The Court and the City'.

9 For an interesting study of Lord Rochester's libertinism see Johnson, J.W., 'Lord Rochester and the Tradition of Cyreniac Hedonism, 1670–1790', in *Studies on Voltaire and the Eighteenth Century* 153 (1976): 1151–67.

10 My interpretation of this passage of history on British Epicureanism is much dependent upon Randolph Trumbach's *Sex, Gender and Revolution*, Chicago 1998, ch.3, 'Male Libertinism'.

Chapter Two: The Ideals and Realities of Self-Improvement

1 Anon., *The Young Gentleman and Lady Instructed*, London 1747, vol.II, p.207.

2 The seminal study of the problem of 'the open élite' is Lawrence Stone's *An Open Elite? England 1540–1880*, Oxford 1984.

3 For further reading concerning the causes and outcomes of the 'Glorious Revolution', see Miller, J., *The Glorious Revolution*, London and New York 1983, and Hilton-Jones, G., *Convergent Forces: Immediate Causes of Revolution of 1688 in England*, Iowa 1990.

4 The idea that the eighteenth century witnessed the rise of 'public opinion' and that the bourgeoisie controlled this amorphous entity has been popular since the publication of Jurgen Habermas's *Structural Transformations of the Public Sphere: An Enquiry into a Category of Bourgeois Society* (1962), trans. Thomas Burger, Cambridge Mass. 1989.

5 The best argument in favour of regarding eighteenth-century Britain as a culture dominated by the aristocracy is Cannon, J., *Aristocratic Century: The Peerage in Eighteenth Century England*, Cambridge 1984.

6 I here refer to Fielding's views as expressed in *An Enquiry into the Cause of the Late Increase in Robbers* of 1751.

7 The standard point of procedure for the study of crime and punishment in eighteenth century England is Hay, D. and Linebaugh, P., eds., *Albion's Fatal Tree: Crime and Society in Eighteenth-Century England*, New York 1975.

8 For an account of this problem see Lane, J., *Apprenticeship in England, 1600–1914*, London 1996.

9 The best indication that Hogarth achieved kudos from being self-taught emerges from a poem by Joseph Mitchell entitled *Three Poetical Epistles: To Mr Hogarth, Mr Dandridge, and Mr Lambert, Masters of the Art of Painting*, London 1730. This includes the lines, 'Self-taught, in your great art excel,/ And from all your rivals bear the Bell.'

10 Thornhill's forebears had lost the family estates, and he was much praised at his death for using the money he had earned to re-purchase the lost estate. He became MP for Weymouth and Melcombe Regis, retaining his seat from 1722 until his death in 1734.

11 That Hogarth became a governor of Bedlam is not generally known. His name does, however, appear in the Court Books of the charity in this capacity.

12 Nichols, J.B., *Anecdotes of William Hogarth, Written by Himself*, London 1833, 59.

13 See Hogarth's own description of his motivations in this respect in Nichols, *Anecdotes of Hogarth*, 13.

14 *Ibid.*, 6.

15 *Ibid.*, 31.

16 *Ibid.*, 14–15.

17 The most convenient and useful version of this text is the paperback edition with an introduction and notes by Ronald Paulson. This was published under the title *William Hogarth: The Analysis of Beauty*, New Haven and London 1997.

18 The comparison of Hogarth's delusions of grandeur with those of Don Quixote may well have derived from the comparisons drawn by Hogarth's apologists between him and Cervantes. See *Gray's Inn Journal*, vol.11, no.67.

19 For Hogarth's opinion of his critical treatment over the *Analysis* and *Sigismunda* see Nichols, *Anecdotes of Hogarth*, 48, 54–5.

20 Hogarth himself stated that 'The leading points in these, as well as the two preceding prints (*Gin Lane* and *Beer Street*), were made as obvious as possible, in the hope that their tendency might be seen by men of the lowest rank.' Nichols, *Anecdotes of Hogarth*, 64.

Chapter Three: 'Britophil'

1 A transcript of this letter can be found in Nichols, *Anecdotes of Hogarth*, 39–42.

2 This letter was reprinted in the *Weekly Register* of June 8, 1734.

3 The word 'unmeaning' is commonly employed by Ralph in *A Critical Review of the Publick Buildings, Statues and Ornaments of London and Westminster*, London 1734.

4 Nichols, *Anecdotes of Hogarth*, 30.

5 Hogarth's association with Spiller is most notably recorded in an early engraving entitled *For the Benefit of James Spiller*, 1720.

6 My comments here are much inspired by Kein, J.B., *Dramatic Satire in the Age of Walpole*, Iowa 1976.

7 Addison, J., *Spectator* no.26, 30 March 1711. This article, and the comments on the Shovel monument, were quoted favourably by Ralph in the *Critical Review*.

8 *Weekly Register*, 13 June 1734.

9 I base much of this on the interpretation of the print in *An Explanation of Several of Mr Hogarth's Prints*, London 1785, 35–6.

10 This comment does, of course, allude to the evolution of the concept of 'the novel'. Two old but good books can be consulted as to the basic narrative of this evolution: Allen, W., *The English Novel*, London 1954, and Church, R., *The Growth of the English Novel*, London 1951.

11 For an account of the use of the English stage as a 'mirror' of human failings see the important but anonymous *A Vindication of the Stage*, London 1698.

12 I rely on the analysis of Diane Waggoner in 'Hogarth's Beggar's Opera Paintings and the Italian Opera', in Bindman, D., ed., *'Among Whores and Thieves': William Hogarth and The Beggar's Opera*, New Haven 1997.

13 Nichols, *Anecdotes of Hogarth*, 2.

14 The two most consulted books on the phenomenon of the rise of nationalism in Britain include ample reference to Hogarth: Colley, L., *Britons : Forging the Nation 1707–1837*, London 1992, and Newman, G., *The Rise of English Nationalism: A Cultural History 1740–1830*, London 1987.

15 Nichols, *Anecdotes of Hogarth*, 45.

16 See Walpole's critique as printed in *ibid.*, 71.

17 *Ibid.*, 62–3.

18 For a fuller range of my arguments in this respect refer to Craske, M., 'Plan and Control: Design and the Competitive Spirit in Early and Mid-Eighteenth-Century England', *Journal of Design History*, vol.12, no.3, 1999, 187–216.

19 For a classic statement of this position see Henry Cheere's speech of 1756 to the Society for the Encouragement of Arts, Manufactures and Commerce. This is preserved in vol.1 of Dr Templeman's transactions which are held in the archives of that Society.

20 Nichols, *Anecdotes of Hogarth*, 8–9.

21 A fine account of the various types of literary satire and Hogarth's response to this tradition appears in Bindman, D., *Hogarth and his Times*, exh. cat. British Museum 1997, ch.3, 'Politeness and Roman Satire'.

22 *Examiner*, no.38.

23 Quoted in P.K. Elkin's *The Augustan Defence of Satire*, Oxford 1975.

24 Anon., *Pug's Reply to Parson Bruin* (Bodleian Vet. A5 D36), London *c*.1763, 5.

25 See the account of the pug in Brown, T., *Biographical Sketches and Authentic Anecdotes of Dogs*, London, 1829, 454; also Anon., *The Sportsman's Cabinet*, London 1804, 122.

26 Bewick, T. and Beilby, R., *A General History of Quadrupeds*, Newcastle 1790, 121.

27 *Pug's Reply*, 6.

28 For an account of the association of satire with 'trimming', or the medium political course, see P.K. Elkin's excellent work, *The Augustan Defence of Satire*.

29 I find Bindman's views on Hogarth's political attitudes the most convincing. These are summarised in Bindman, D., *Hogarth and his Times*, ch.4, 'Hogarth and the Spirit of Party'.

30 For the association of personal satirical attack with a 'low' temperament see Joseph Addison in the *Spectator*, no.23.

Chapter Four: Liberty and Libertinism

1 Lawrence Klein's *Shaftesbury and the Culture of Politeness: Moral Discourse and Cultural Politics in Early Eighteenth-Century England* (Cambridge, Mass. 1994) is generally considered a seminal work in this sort of definition of the age.

2 Trusler, J., *The Principles of Politeness*, Dublin 1775, 20.

3 This view of Hogarth has been promoted by David Solkin in *Painting for Money*, New Haven and London 1993, ch.3, 'Hogarth's Refinement'.

4 Randolph Trumbach's *Sex and the Gender Revolution*, Chicago 1998.

5 The manuscript of the journal kept of this trip has been published with an editorial by Charles Mitchell: Mitchell, C., *Hogarth's Peregrination*, Oxford 1952.

6 The sacrilegious activities of libertines are noted in Trumbach, *Sex and the Gender Revolution*, 82.

7 An account of Dashwood's Hell-fire Club appears in Kemp, B., *Sir Francis Dashwood*, London 1967.

8 *The Gentleman and Lady Instructed*, London 1747, vol.II, 179.

9 In the mid-eighteenth century becoming a Rake was associated with the loss of rational control. The author of *The Young Gentleman and Lady Instructed* (vol.I, 354) stated that a man turned himself into a Rake through allowing the gradual loss of rational powers, which caused him to be seduced by 'the strength and force of a lively imagination, which hurries him to unlawful pleasure'.

10 Dabydeen, D., *Hogarth, Walpole and Commercial Britain*, London 1987.

11 The best general account of the South Sea affair remains David Carswell's *The South Sea Bubble*, London 1960.

12 Latitudinarianism is often considered the dominant theology of early and mid-eighteenth-century England. It indicates a belief that Protestantism should exhibit a tolerant and inclusive attitude on matters of doctrine. This ideal was contrasted with 'enthusiasm', a religious attitude parodied by Hogarth, which was regarded as the tendency to let passion draw one into religious fanaticism. Ironically, Latitudinarian preachers were generally intolerant of Catholics, who were dismissed as partakers in an 'enthusiastic' perversion of 'primitive' Christianity.

13 Like most theological concepts of eighteenth-century England that of 'providence' has far too limited a literature. One major English literature scholar, Martin Battestin, has, however, taken a strong interest in this subject and applied it to literary figures with whom Hogarth was very familiar. For these views see Battestin, M.C., *The Moral Basis of Fielding's Art*, Connecticut 1975, and *The Providence of Wit*, Oxford 1974.

14 Trusler, J., *The Works of William Hogarth*, London 1833, 90.

15 *The Gentleman and Lady Instructed*, vol.II, 142–3.

16 Anon., *An Explanation of Several Of Mr Hogarth's Prints*, London 1785

17 *Ibid.*, 82.

18 The author of *An Explanation of Several of Mr Hogarth's Prints* identifies him.

19 A basic account of Laroon and *The Cryes of London* is available: Rane, R., *Marcellus Laroon*, London 1960.

20 For a good basic account of the state of the British army in this period consult Bowen, H.V., *War and British Society 1688–1815*, Cambridge 1998.

21 *London Magazine*, 1746, 228.

22 Nichols, *Anecdotes of Hogarth*, 58.

23 The best accounts of Wilkite politics remain Rudé, G., *Wilkes and Liberty*, Oxford 1962, and Brewer, J., *Party Ideology and Popular Politics at the Accession of George III*, Cambridge 1976.

24 A good basic account of the Election series has been published in Christina Scull's *The Soane Hogarths*, London 1991.

25 *An Explanation of Several Of Mr Hogarth's Prints*, 75.

26 *Gray's Inn Journal*, vol.II, no.95.

27 *London Magazine*, 1749, 381.

28 The first cultural historian to take a strong interest in Shaftesbury's commentaries on 'The Choice of Hercules' was John Barrell in *The Political Theory of Painting from Reynolds to Hazlitt: The Body of the Public*, New Haven and London 1989.

Chapter Five: Hogarth's Sympathy for, and Afinity with, the 'Nobodies' of Society

1 A fuller account of Hogarth's involvement with the Foundling Hospital can be found in ch.16 of Jenny Uglow's biography of the artist.

2 The case for this policy is made in a press release by the Hospital printed in the *Gentleman's Magazine*, 1753, 234.

3 A good review of these prints appears in David Solkin's *Painting for Money*, 161–4.

4 This observation is based on my own observations while researching into prominent London hospitals of this period.

5 Anon, *The Gentleman's Library, Containing Rules of Conduct in all Parts of Life*, London 1744, 365.

6 There is no literature on this monument. Stylistically it can only be a work of Henry Cheere (1702–81), whose firm made a fireplace with a similar dog which recently came to auction. Cheere made the monument to the wife of Admiral Rodney which was erected on a nearby wall.

7 A note of this play appears in the biography of Benjamin Hoadly in the *Dictionary of National Biography*. The play remains unpublished.

8 Brown, J., *An Estimate of the Manners and Principles of the Times*, London 1757.

9 Gerald Newman adopts this view of Hogarth in *The Rise of English Nationalism*. The 'old left' vision of Hogarth as class warrior is best seen in Frederick Antal's *Hogarth and his Place in European Art*, London 1962.

10 *The Young Gentleman and Lady Instructed*, vol.ii, 84–6.

11 An illustration of this painting can be found in Allen, B., *Francis Hayman*, New Haven and London 1987, 98, fig.19.

12 A play on the word 'Hog-art' appears in one of Sandby's satires on Hogarth entitled *The Analyst Besh–n: in his own taste* (1753). In the lower corner we see a figure of an idiot, labelled 'Hog-art', riding a pig. The figure faces backward and lifts the tale of the pig to show its anus.

Select Bibliography

Atherton, Herbert, *Political Prints in the Age of Hogarth*, Oxford 1974

Bindman, David, *Hogarth*, London 1981

Brewer, John, *Pleasures of the Imagination: English Culture in the Eighteenth Century*, London 1997

Burke, Joseph (ed.), William Hogarth, *The Analysis of Beauty*, Oxford 1955

Einberg, Elizabeth, *Hogarth the Painter*, exh. cat. Tate Gallery, London 1997

George, Dorothy, *English Political Caricature to 1792*, Oxford 1959

Hallet, Mark, *The Spectacle of Difference*, New Haven and London 1999

Mitchell, Charles (ed.), *Hogarth's Peregrination*, Oxford 1952

Nichols, John, *Biographical Anecdotes of William Hogarth with a Catalogue of his Works*, London 1781, 1982, 1785

Paulson, Ronald,*Hogarth*, 3 vols., Rutgers 1991–3

Solkin, David, *Painting for Money*, New Haven and London 1993

Photographic Credits

Index